NEW TWISTS on
TWINED
KNITTING

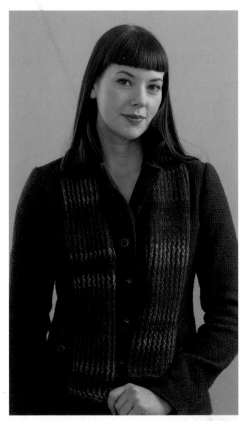

NEW TWISTS on
TWINED

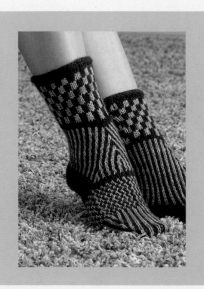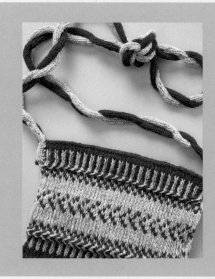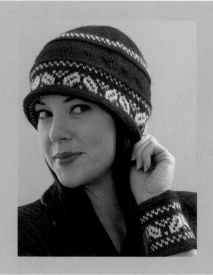

KNITTING

A Fresh Look at a Traditional Technique

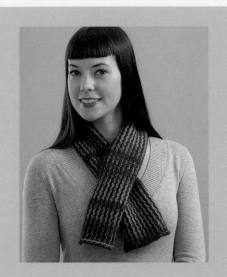 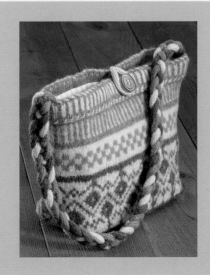 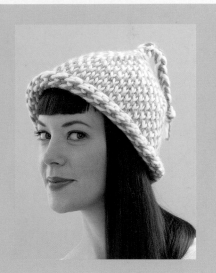

LAURA FARSON

Martingale®
& COMPANY

New Twists on Twined Knitting:
A Fresh Look at a Traditional Technique

© 2009 by Laura Farson

Martingale®
& COMPANY

Martingale & Company®
20205 144th Ave. NE
Woodinville, WA 98072-8478 USA
www.martingale-pub.com

CREDITS

President & CEO » Tom Wierzbicki

Editor in Chief » Mary V. Green

Managing Editor » Tina Cook

Technical Editor » Robin Strobel

Copy Editor » Marcy Heffernan

Design Director » Stan Green

Production Manager » Regina Girard

Illustrator » Adrienne Smitke

Cover & Text Designer » Stan Green

Photographer » Brent Kane

Printed in China

14 13 12 11 10 09 8 7 6 5 4 3 2 1

Library of Congress Cataloging-in-Publication Data

Library of Congress Control Number: 2009013162

ISBN: 978-1-56477-870-3

MISSION STATEMENT

Dedicated to providing quality products and service to inspire creativity.

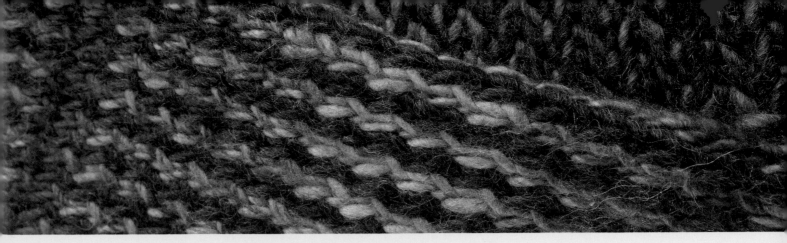

Acknowledgments

Thanks to the following who contributed to the completion of this book:

Judy and Maggie at Shuttles.

Dennis and Fran Finnigan for their photographic assistance.

The Tuesday Library Knitters: Dixie, Shirley, Patty, Betsy, Ruth, Kay, Shaun, and Sandra.

Friendly test knitters: Margaret, Barb, Carolyn, Linda, and Sandy.

Special thanks to Cat Bordhi for her sock architecture and JC Briar Knitting for tips on knitting thumbs.

For their donation of yarns:

Shannon and Jean Dunbabin and Helen Nickerson of Cascade Yarns

Marilyn King of Black Water Abbey Yarns

Arnhild Hillesand of Rauma Yarn

Paul Nichols of Mission Falls Yarn

Kristine Brooks of Curious Creek Yarns

Diana Milano of Karabella Yarns

Therese Chenowyth of Dale of Norway

Leslie Taylor and Diana McKay of Mountain Colors

Cheryl Potter of Cherry Tree Hill

Norah Gaughan of Berroco

Very special person Robin Strobel who improved this book by knitting it!

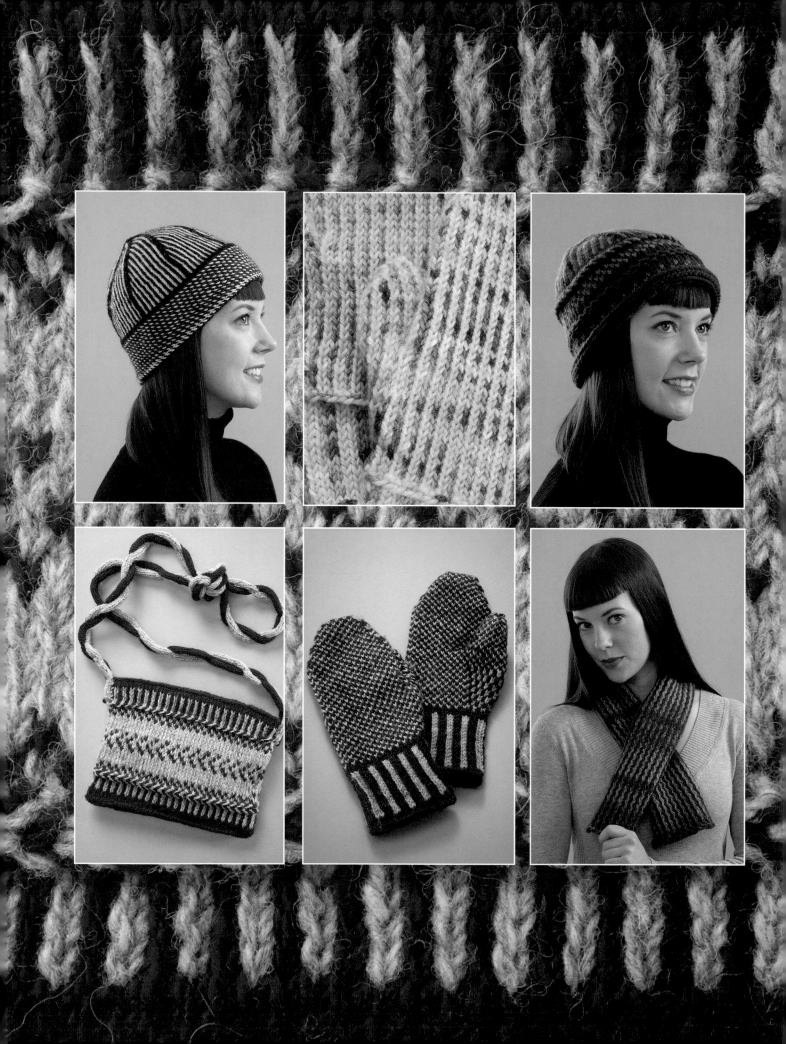

Contents

Projects

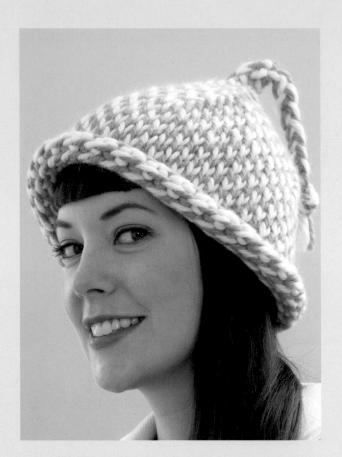
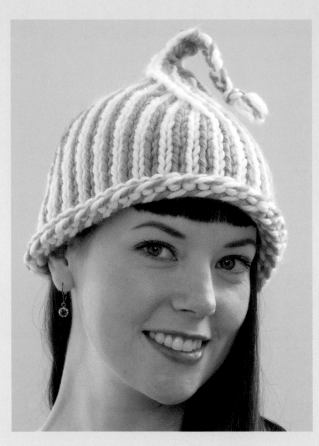

Inside (below) and outside (above) of Basic Blue-and-White Checked Hat and Striped Hat Variation, pages 39 and 40

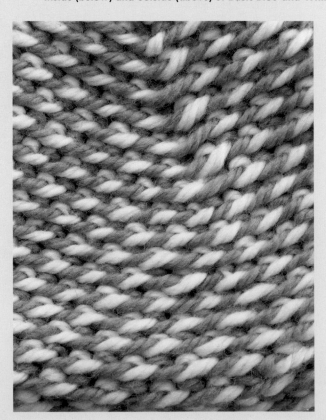
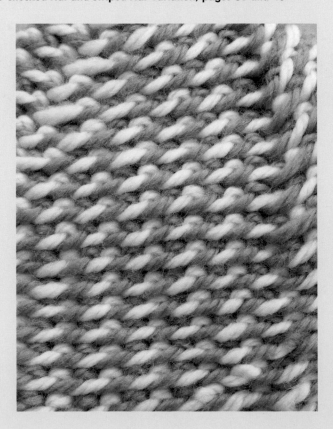

Introduction

"Two-end," "twisted," or "twined" knitting is made with two strands of yarn, either from both ends of a single ball of yarn or from two separate balls. You knit one stitch with one strand and the next stitch with the second strand using the right hand in the so-called English or "throwing" style. As you knit, each strand is twisted around the other on the wrong side of the work. The resulting fabric is thicker and warmer than fabric knit with a single strand of yarn. While thick and dense in some patterns, it's still elastic and soft. The knitting wears well and retains its shape even with hard use.

Twined knitting is an old technique recently rediscovered in the remote area of Dalarna in Sweden. This technique nearly died out while Continental-style knitting was taught exclusively in schools. Its rediscovery has captured the interest and enthusiasm of knitters around the world.

Traditional twined knitting is made with only one color; yarn is pulled from both ends of a center-pull ball of yarn. Beautiful patterns are made with intermittent purl stitches among the stockinette or with an entire purl row, which creates a braidlike texture.

I love twine knitting with two colors—often one solid and one variegated. There seems to be an unlimited number of possible variations of color and texture. The wrong side of a twined-knit project is very attractive, and in some cases the garment is worn inside out! Once you master the basics, I'm sure you will want to experiment.

On the right side of the work, twined knitting with two colors can look similar to stranded knitting, but I find it is easier to keep an even tension when twining. Twined knitting is also ideal for colorwork in socks and hats because it creates a fabric with more elasticity than stranded methods.

In this book you'll find both basic projects and more complicated ones that extend beyond traditional methods. The Media Case or Wrist Warmers practice project on page 34 is a perfect way to learn twined knitting basics. I've provided an easy pattern with just one color for a traditional hat and simple variations using two colors. Once you've mastered the technique, there are projects for mittens, more complex hats, a headband, socks, scarves, and accessories. I've given you some bulky-yarn projects that knit up quickly and other projects that use thick and thin yarns and stitch patterns to create texture. Many of the projects broaden the scope of traditional twined knitting by combining different weights and colors of yarns.

TWINED KNITTING SIMPLIFIED

• Twined knitting uses two strands knit separately; they may be the same or different colors and weights.

• Casting on uses both strands.

• Twined knitting projects are usually worked in the round.

• Both strands are carried in the right hand and knit with the English ("throwing") method.

• Each stitch alternates between the two strands of yarn.

• With each stitch, one strand is lifted over the other one, creating a twist on the inside of the work.

• Periodically the strands between the work and yarn balls have to be untwisted.

• From the right side, twined stockinette stitch looks similar to conventional stockinette, but twined stitches are slightly elongated, making the stitch gauge nearly equal to the row gauge.

• The stitches are remarkably even and create a thick, warm, and elastic fabric.

Getting Ready for Twined Knitting

Most of the projects in this book are knit in the round with wool or wool blends. Much of the knitting is done on one circular needle, but hats and small projects will require two circular needles or double-pointed needles.

YARN CHOICES

Traditionally, twined knitting was made with fine wool yarns, but today we have many suitable yarns to choose from. For this book, I've stayed with wool and wool blends for their stretch. The super-bulky yarns I use are plied. I once made a hat with unplied bulky yarn and it almost exploded when wet. Now I have a hat that will fit a basketball! Plied bulky yarns don't have this problem.

It's advantageous to use yarns with smooth surfaces, but I've mixed fuzzy and smooth yarns with fine results. If you choose a "hairy" yarn, it's important to be very careful knitting the pattern, as ripping out is difficult and usually leaves a trail of color. Another advantage to a smooth yarn is that it's easier to untwist the strands than if you used a fuzzy yarn like mohair.

Bumpy and feathery yarns are difficult to twist and untwist (but I haven't ruled them out yet!). As we continually update the technique, almost anything is possible. Most exciting for me is mixing a thick yarn with a thin yarn. This forms attractive textural shading and can give the impression of pile.

BOBBINS AND BALLS

If you use only one color, you can pull a strand from each end of a single center-pull ball. But when you twine knit, the strands twist around each other between your work and the ball. That, combined with the twist of plied yarns, will cause kinking. You have to stop periodically and unkink the strands. Instead of using just one ball, I prefer working from two individual balls or from two large knitting bobbins because it is easier for me to untwist and unkink the yarn.

If you're starting with a hank of yarn that's not already wound into a ball, use a ball winder to make individual center-pull balls or hand wind the yarn onto large bobbins.

Bobbins work best for thinner yarns. I pack as much as I can onto the bobbin, and then use a piece of masking tape to keep it from unwinding. (Packing the bobbin makes for fewer yarn ends to hide, though I have to peel back the tape to pull more yarn from the bobbin.) Thick yarns, such as bulky or super bulky, fill a bobbin too fast, so I just use balls. However, bulky yarns knit up quickly and don't kink as tightly as thin yarns when pulled from balls.

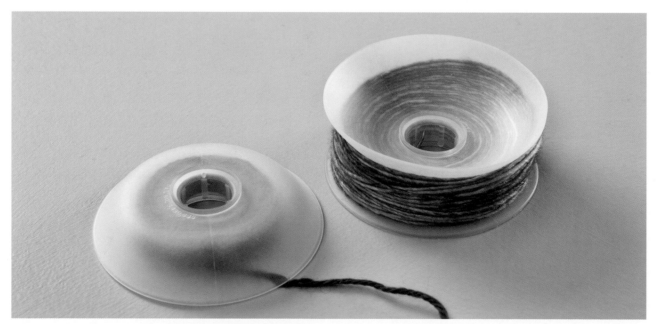

Large bobbins make untwisting light- and mediumweight yarns easy.

Casting On

I recommend you use both strands of yarn and one of the following methods to cast on, but if you prefer, you can use your favorite, fairly elastic cast-on technique and pick up the second strand of yarn at the beginning of your first row.

The key to a good cast on is that it needs to be stretchy. I like the two-strand long-tail cast on for projects that need an average amount of stretchiness. The twisted German cast on has more stretch and works well for socks. The removable, or provisional, cast on is used for an edge that will later be grafted to another or picked up and knit. When this cast on is removed, it leaves live stitches ready to place on a needle.

SLIPKNOT

The slipknot is only temporary in twined knitting. You will start your cast on with it, *but don't count it as a cast-on stitch*. To make a slipknot, hold the two strands of yarn together and make the same type of slipknot as in regular knitting.

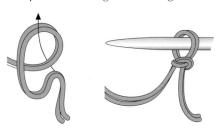

TWO-STRAND LONG-TAIL CAST ON

1. Holding two strands of yarn together (two main-color strands or one each of the main color and contrast color), make a slipknot approximately 4" from the ends.

2. Place the slipknot on a needle held in your right hand. Hold both strands of yarn in your left hand, with the main color strand held over your thumb and the other strand held over your index finger. This will create a main-color edge. Hold the strands in your palm to keep them snug.

3. Insert the right needle into the front of the loop on your thumb and over the yarn on your index finger.

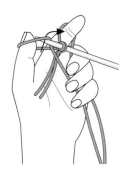

4. Bring the index-finger strand through the loop on your thumb, forming a loop on the needle; snug the strands. You have cast on one stitch.

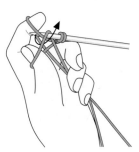

5. Cast on the number of stitches specified for your project. Remember, the slipknot does not count as a cast-on stitch. It will be removed before you start knitting. The yarn that was over your thumb forms the bottom edge of the knitting, and the yarn that was over your index finger runs across the needle.

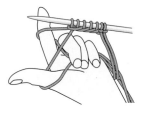

5 cast-on stitches

TWISTED GERMAN CAST ON

1. Holding two strands of yarn together (two main-color strands or one each of the main color and the contrast color), make a slipknot approximately 4" from the ends.

2. Place the slipknot on a needle held in your right hand. Hold both strands of yarn in your left hand, with the main color strand over the thumb and the other strand over your index finger. This will create a main-color edge. Hold the strands in your palm to keep them snug.

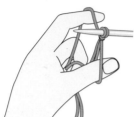

3. Put the needle under both strands of the thumb yarn, and then bring the tip of the needle up over the back of the thumb strand and down through the loop.

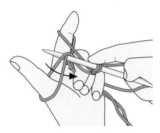

4. Swing the tip of the needle up toward you, then over the top of the closest index-finger strand, picking up that strand.

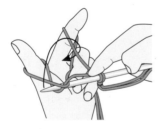

5. Bend your thumb toward your index finger to relax the twist in the thumb strand, and then bring the tip of the needle back down through the thumb loop, weaving through the twist so only the index-finger yarn is on the needle.

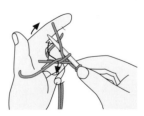 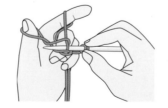

6. Drop the thumb loop and snug the yarns up against the needle. Repeat for the required number of stitches. Remember not to count the slipknot as a cast-on stitch as it will be dropped before beginning to knit.

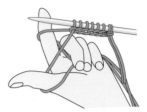

6 cast-on stitches

PRETTY EDGES

My favorite cast-on combination looks like a pretty blanket-stitched edge. Cast on with two contrasting colors using either the twisted German or two-strand long-tail cast-on method. Slip the first stitch purlwise, join in the round, and twine purl with both colors for the first round. Twine purl into the first stitch of the second row. Switch to two strands of the same color and twine knit the next three to five rounds in one color.

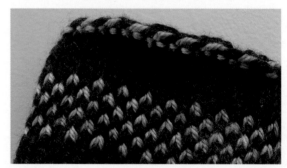

Wrist warmer (page 34) with my favorite edging

REMOVABLE CAST ON

I use this cast on for the Nubby Headband, shown on the facing page (see page 56 for instructions). After the headband is knit, the waste yarn is removed and the two ends are grafted together for a seamless join. Use a smooth, slightly contrasting yarn for the cast on or it will be difficult to remove, and there will be fibers of a different color in your project.

1. Make a slipknot with a single strand of waste yarn about 6" from the end and place it on a crochet hook. Hold the knitting needle in your left hand and the crochet hook in your right hand, with the crochet hook on top of the knitting needle. Bring the strand under

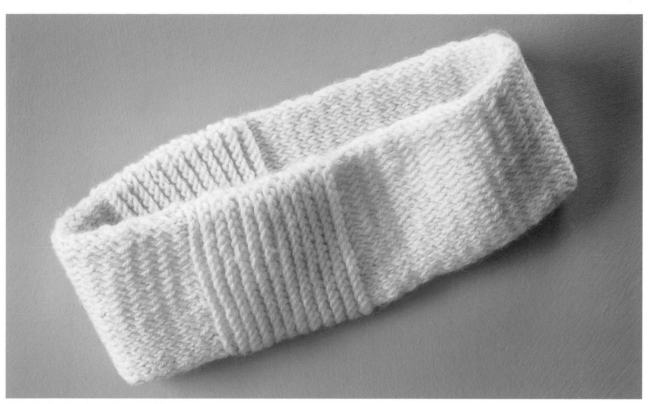

The tubular headband is invisibly joined in a circle with the Kitchener stitch.

the tip of the knitting needle. Use the crochet hook to draw a loop over the knitting needle and through the slipknot. You have cast on one stitch.

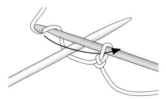

Bring loop through slipknot.

2. Bring the yarn back under the tip of the knitting needle. With the crochet hook on top of the knitting needle, draw a loop over the knitting needle and through the loop on the crochet hook. Repeat, casting on the number of stitches specified in the instructions.

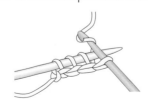

The fourth stitch is being cast on.

3. At the end of the cast-on row, use the crochet hook to chain about 5 stitches, and then cut the waste yarn. This is the end you will pull when undoing the cast on. Alternating two strands, twine knit across the row and join in the round at the end of the row. When the knitting is complete, gently pull the end of the waste yarn to unravel the chain. Use a knitting needle to pick up each loop of the project yarn as the waste yarn is pulled free.

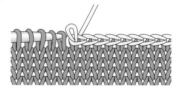

Gently pull waste yarn and place each stitch on the needle as it comes free.

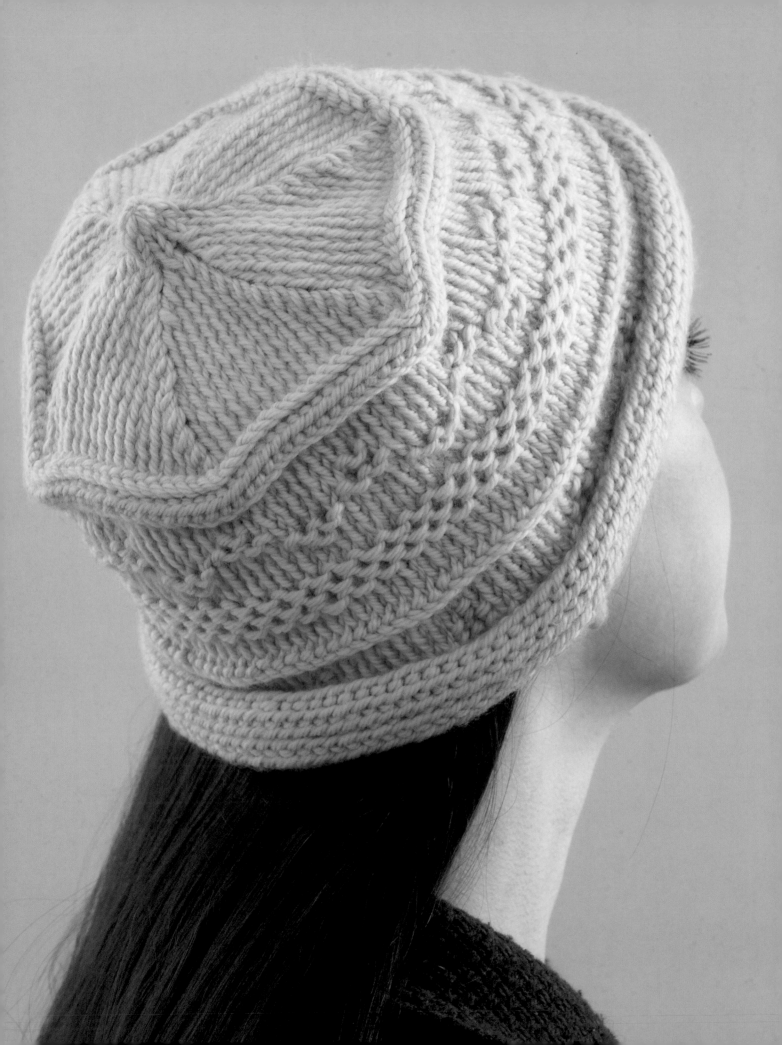

Knitting in the Round

Twined knitting was traditionally knit in the round with either one circular needle or, if the project was small, four or five double-pointed needles. Except for the scarves, all of my projects are worked in the round. So before you start twining, it is best if you are familiar with this method of knitting. If the project is too small to fit on one circular needle, I prefer to use two circular needles instead of double-pointed needles; but I'll describe both methods.

KNITTING ON ONE CIRCULAR NEEDLE

Projects with large diameters, like the Blue-and-White Striped Neck Gaiter on page 37 or the wide part of a hat, are easily knit on one circular needle.

1. Use the cast-on method specified in the project and cast onto the circular needle the required number of stitches.

2. Slide the first few cast-on stitches to the end of the needle held in your left hand. Slide the slipknot off the needle and tug gently to undo it.

3. Check to be certain none of the stitches are twisted around the cable. Begin to work in the round by slipping the first stitch purlwise from the left needle to the right needle. You may want to place a stitch marker to indicate the beginning of each round. I prefer to simply look for the beginning tail of yarn.

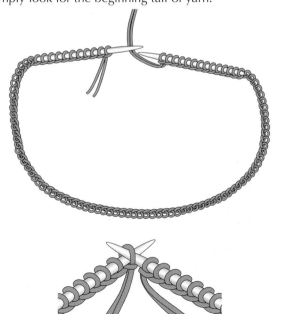

4. Your first knit stitch joins the cast-on stitches in a circle. Knit around, and knit into the slipped stitch to complete one round.

TWO CIRCULAR NEEDLES

If the project is too small to fit on one circular needle, I like to knit on two circular needles. In this technique, the yarn is divided between the two needles. When knitting the yarn on the first needle, you will knit with the other end of that circular needle. When knitting the yarn on the second needle, you will knit with the other end of that needle.

1. Cast the required number of stitches onto one circular needle. Undo the slipknot. Carefully slip half the stitches purlwise to a second circular needle.

2. Slide the stitches along the cables to the other end of the circular needles. With your left hand, hold the needles parallel, being careful the stitches don't twist around the needles. Needle 1 is below needle 2, with the working yarns on needle 2.

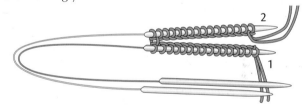

3. Hold the free end of needle 1 in your right hand, and let the unused end of needle 2 dangle. Check to be certain none of the cast-on stitches is twisted around the needles. Slip the first stitch from needle 1 purlwise to the other end of the same needle and snug up the yarn.

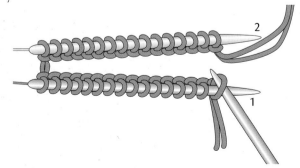

Slip stitch purlwise from needle 1 to the other end of the same needle.

4. Checking again that the stitches on the needles are not twisted, knit the first stitch from needle 1 and snug up the yarn. Slide the remaining stitches on needle 2 down on the cable so they don't slide off, and release needle 2. Knit to the end of the cast-on stitches placed on needle 1. After the last stitch, slide the stitches down to the cable part of needle 1 so they don't slide off.

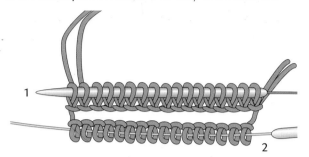

Slide stitches from needle to cable.

5. Slide the cast-on stitches to the left end of needle 2 and rotate the work so the stitches on needle 2 are ready to be knit. Hold the needle with stitches in your left hand, with the free end in your right hand. Needle 1 can dangle free.

6. Check once again to be certain the cast-on stitches are not twisted around the needles. As you begin to knit on needle 2, snug up the yarn on the first two stitches.

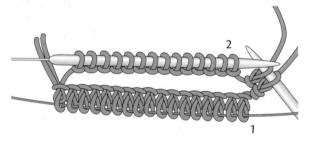

Snug the yarn after knitting
the first 2 stitches on needle 2.

7. Continue knitting around the work in this manner, knitting the stitches on one needle, and then rotating the work and knitting the stitches on the other needle. After the first few rounds, you no longer have to worry about the stitches twisting around the needles.

DOUBLE-POINTED NEEDLES

Some of you may prefer using double-pointed needles instead of two circular needles to knit the smaller projects. Cast the stitches on one double-pointed needle, and then distribute them evenly on three or four needles. Join in the round using an additional needle to do the knitting. Knit the stitches on one needle while ignoring the rest, and then turn your work and knit the stitches on the next needle.

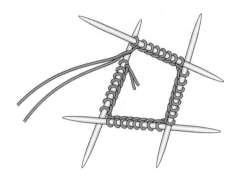

Cast-on stitches distributed
evenly on 4 needles

How to Twine Knit

The mechanics of a twined knit or purl stitch are no different than the throwing method of knitting. What is different is handling the two strands of yarn and creating the twist between the stitches. As soon as you understand the concept, I suggest you try the first "Practice Project" on page 34. I think you will be surprised at how quickly you master this technique!

THE TWINED KNIT STITCH (TK)

All but one project are worked in the round, which is taken into account in these instructions. However, for ease of viewing, the art is simplified to show the knitting flat. As you begin, remember to not knit into the slipknot. If knitting in the round, slide the slipknot off the needle and tug gently to unravel it. If knitting back and forth, take the slipknot off the needle at the end of the first row.

When you twine knit, you knit one stitch with one strand and the next stitch with the other strand. The strands alternate every stitch. The instructions will refer to a "front strand" and a "back strand." The front strand comes from the last stitch you knit (the first stitch on the right needle). The back strand comes from the stitch knit before that (the second stitch on the right needle.) You will use the back strand to make the next stitch.

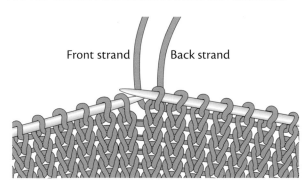

Front strand Back strand

1. Cast on with two strands of yarn using either the "Two-Strand Long-Tail Cast On" (page 13) or the "Twisted German Cast On" (page 14). Remove the slipknot.

2. Hold the needle with the cast-on stitches in your left hand. The working strands of yarn and the second needle are held in your right hand. Slip the first cast-on stitch purlwise from the left needle to the right needle. You may find wrapping the two yarns once around your little finger helps keep an even tension.

3. Hold the yarn to the back of the work and insert the tip of the needle held in your right hand into the first stitch on the left needle, from front to back (knitwise), as in a conventional knit stitch.

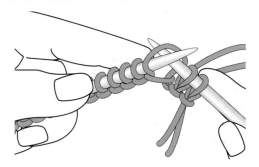

Right needle inserted in stitch "as if to knit"

4. Lightly pinch the *back* strand of yarn between your right thumb and forefinger. Lift it *over* the front strand (blue over gold), wrap it counterclockwise around the needle tip and make a knit stitch, slipping the yarn off the left needle.

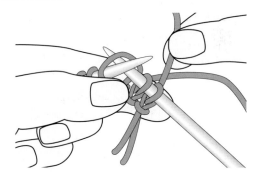

Lift "back" strand over "front" strand.

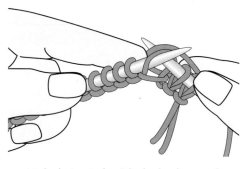

Make knit stitch with the back strand.

5. For the next stitch, the strands switch places, so the stitch is formed with the new back yarn (gold). Make the stitch the same way as in steps 3 and 4, inserting the needle, bringing the back strand over the front strand, and making the stitch.

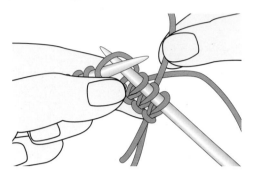

Lift "back" strand over "front" strand.

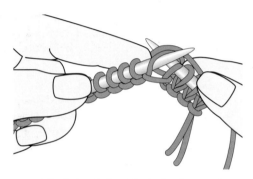

Make knit stitch with the back strand.

6. Continue knitting in this manner, changing strands with every stitch and bringing the back strand over the front. This is what creates the twist on the back of the work. *Always twist the yarns in the same direction: back strand over front strand when working the knit stitch,* unless instructed otherwise.

7. As you practice, you will probably start thinking about how to make picking up the strands easier. One way is to use the middle finger on your right hand to separate the two strands. Experiment and decide what works for you.

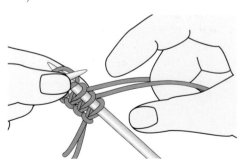

GAUGE SWATCH

Depending on the yarn, the twining stitch and row gauges are often the same—the width of a stitch is the same as the height. (In conventional knitting the stitches are wider than they are tall.) Therefore, it is especially important to knit a test swatch before you start your project. If the project is knit in the round, make your swatch the same way; knitting flat will distort the gauge and your swatch will not be accurate.

THE TWINED PURL STITCH (TP)

Like the knit stitch, the twined purl stitch mechanics are basically the same as in conventional English-style knitting. The strands of yarn alternate for each purl stitch just like in the twined knit stitch. The difference is in making the twist; when knitting in the round, the back strand is carried *under* the front strand instead of *over* it.

1. Bring both strands to the front of the work, but do not twist them. Insert the tip of the needle held in your right hand into the stitch, from back to front (purlwise), as in a conventional purl stitch.

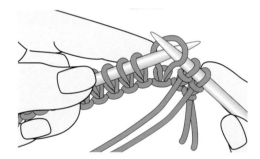

Right needle inserted in stitch "as if to purl"

FIXING MISTAKES

If you drop a stitch, pick up the loop with a crochet hook. Pull the appropriate bar of yarn through the loop in the direction of the stitch on either the knit side or the purl side. If you are working with two colors, it will be easy to tell which bar to pick up. If you are working with one color, pick up the longest bar. The yarns have already been twined.

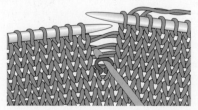

2. Lightly pinch the back strand of yarn between your right thumb and forefinger. Carry it *under* the front strand (blue strand under gold strand), wrap it counterclockwise around the needle tip, and make a purl stitch, slipping the yarn off the left needle.

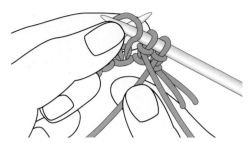

Bring "back" strand under "front" strand.

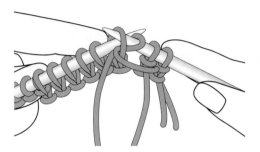

Make a purl stitch with the back strand.

3. For the next stitch, the strands switch places; the next stitch is formed with the new back yarn (gold strand under blue strand), making the purl stitch the same way as in steps 1 and 2.

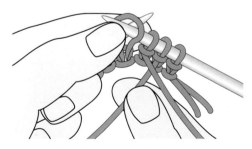

Bring "back" strand under "front" strand.

4. Continue purling in this manner, changing strands with every stitch and bringing the back strand under the front strand to create the twist. *Always twist the yarns in the same direction: back strand under front strand when working the purl stitch,* unless instructed otherwise.

When you switch between knit stitches and purl stitches, be careful to use the strands in order, alternating the strand with each stitch, whether it is a knit stitch or a purl stitch, unless directed otherwise. Your knitting will look a lot smoother if you knit the strands in order.

UNTWISTING THE YARN

It is an unavoidable fact that twined knitting causes the yarns to twist and kink together. Untwisting the yarns eventually becomes part of the rhythm of knitting, but there are techniques to make it less annoying.

First you need to temporarily keep the yarn from unwinding off the ball or bobbin. With bobbins, simply snap them closed and if necessary place masking tape across the edge. For balls, first pull out a working length of yarn (about 2 yards) and wrap it once around the ball. Make a loop slipknot and wrap the loop around the ball. Snug the loop. Repeat for the other ball. (You can also use stretchy ponytail holders to keep the yarn from slipping off the balls.)

Hold the project in the air so the bobbins or yarn balls dangle. Place a finger close to the project and between the strands and gently slide your finger down. The yarns will untwist and the bobbins or balls spiral, relaxing the kinks. Remove the slipknots from around the balls or open the bobbins and pull out additional yarn to continue knitting.

Single-ply yarns may untwist during the knitting. Holding the project in the air as previously described and holding the bobbins or balls apart allows the yarn to retwist itself.

When you make a project, you may shift from working two strands of the main color to one strand of the main color and one of the contrast color for a few rounds, and then go back to two strands of the main color. You have a choice whether to cut one of the main-color strands or to float it up a few rows and pick it up when you are done with the contrast color. If you hate weaving in ends and decide to carry the extra strand up a few rows, untwisting three strands can be messy. Keep the main-color balls on one side of your knitting and the contrast color on the other, and the untwisting will be easier.

Increasing, Decreasing, and Binding Off

The projects in this book use only simple methods for increasing and decreasing. Twined increases and decreases are basically the same as their conventional knitting counterparts. There are just a few minor modifications due to the two strands.

MAKE 1 INCREASE (M1)

Pull the left and right needles slightly apart and look at the first row between the needles. In conventional knitting there would be just one strand between the stitches. In twined knitting there are two strands—one from each ball of yarn. Insert the left-hand needle from back to front under one of these horizontal strands. If you are using two colors, choose the horizontal strand that is the same color as the stitch to be made. If you are using one color, it does not matter which horizontal strand you use. Twine knit through the front of the strand to twist it tight.

This makes an increase that slants to the right. I use this on the right edge of a mitten gusset or sock increase.

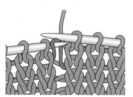 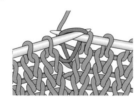

Right-slant make 1 increase

For a make one increase that slants to the left, insert the left-hand needle from front to back under one of the horizontal strands. Twine knit through the back of the stitch. Use the left-slanting increase for the left edge of a mitten gusset or sock increase.

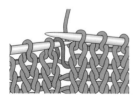 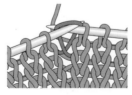

Left-slant make 1 increase

SLIP SLIP TWINE KNIT DECREASE (SSTK)

Slip the first stitch as if to knit from the left needle to the right needle. Repeat with the next stitch on the left needle. Insert the left needle into the front of the two stitches. Twine the strands by bringing the back strand over the front strand (just like a twined knit stitch) and use the back strand to knit the two stitches together as one stitch.

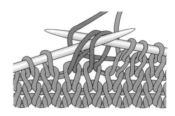

Pick up strand the color of your stitch.
Knit two slipped stitches together.

TWINE KNIT (or Twine Purl) TWO STITCHES TOGETHER DECREASE (TK2tog, TP2tog)

Insert the right needle through the first two stitches on the left needle as if to knit for the knit version and as if to purl for the purl version. Twine the strands by bringing the back strand over the front strand (just like in a twined knit stitch) and use the back strand to knit or purl the two stitches together as one stitch.

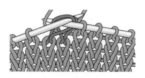 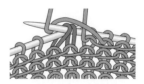

Twine knit 2 together
(TK2tog)

Twine purl 2 together
(TP2tog)

SEWN BIND OFF

This bind off, attributed to Elizabeth Zimmerman, is elastic and neat. I've used it for almost all of the binding off in this book. Unlike knitted methods, you don't want to bind off too loosely. When you pull the yarn snug, try and match the tension on the stitches below.

1. Cut a length of yarn three times the length or circumference of the edge and thread the cut end of the yarn through a tapestry needle.

2. Pull the tapestry needle purlwise through the first two stitches on the left needle. Draw the yarn snug but leave the stitches on the knitting needle.

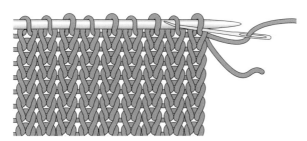

Push needle purlwise through first 2 stitches.

3. Insert the needle knitwise back through only the first stitch. Draw the yarn snug.

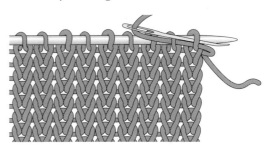

Bring needle knitwise through first stitch.

4. If you are knitting in the round, move the first bound-off stitch to the right knitting needle. (It will be the last stitch bound off.) On all other bound-off stitches (or if not knitting in the round) drop the bound-off stitch from the needle.

Repeat steps 2–4 for all the stitches on the needle. Weave the yarn through to the inside and hide the end.

Additional Knitting and Finishing Techniques

Here are some additional techniques that are used in the projects. Some, like the Kitchener stitch, are common knitting techniques. Others, like the crook stitch, are easy but unusual.

KITCHENER STITCH

The Kitchener stitch is very handy for grafting live stitches together as in the toe of a sock or the tips of mittens. There are no modifications needed for twined stitches. You must have an even number of stitches. If not, decrease one stitch to make the number even.

1. Divide the stitches evenly on two needles. Cut one end of yarn three times the circumference and thread it onto a tapestry needle.

2. Hold the needles parallel, with the tips pointing to the right and the wrong (purl) sides facing inward.

3. Insert the threaded tapestry needle into the first stitch on the needle closest to you (front needle) as if to purl and pull the tapestry needle through, leaving the stitch on the knitting needle.

4. Insert the tapestry needle into the first stitch on the back knitting needle as if to knit. Pull the yarn through, leaving the stitch on the knitting needle.

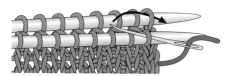

Step 3: Insert tapestry needle in front stitch as if to purl.
Step 4: Insert in back stitch as if to knit.

5. Insert the tapestry needle into the first stitch on the front needle as if to knit and slip the stitch off the end of the knitting needle. Pull the yarn snug, but not tight.

6. Insert the tapestry needle into the next stitch on the front needle as if to purl. Pull the yarn through, leaving the stitch on the knitting needle.

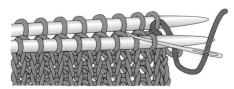

Step 5: Insert tapestry needle in front stitch as if to knit and slip stitch off.
Step 6: Insert in next stitch as if to purl.

7. Insert the tapestry needle into the first stitch on the back needle as if to purl and slip the stitch off the knitting needle. Pull the yarn snug, but not tight.

8. Insert the tapestry needle into the next stitch on the back needle as if to knit and pull the yarn through, leaving the stitch on the knitting needle.

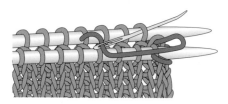

Step 7: Insert tapestry needle in back stitch as if to purl and slip stitch off.
Step 8: Insert in next stitch as if to knit.

Repeat steps 5–8 until all stitches have been grafted together. Insert the needle between the last stitches, to the inside. Turn the work inside out and pull the yarn through. Weave the yarn end into the wrong side of the work.

ZIGZAG PATTERN

When twine knitting, yarns tend to kink and twist together. This is caused by constantly twisting the strands in the same direction. The twisting also causes a slight bias effect in your knitted fabric. Reversing the direction of the twist relieves the bias, untwists the strands, and produces a pretty zigzag stitch pattern.

If you are knitting in the round with twined stockinette stitch, a zigzag pattern can be created by alternating a conventionally twined round of knit stitches (the back strand is brought *over* the front strand) with a reverse twined round of knit stitches (the back strand is brought *under* the front strand). (See photo at top right)

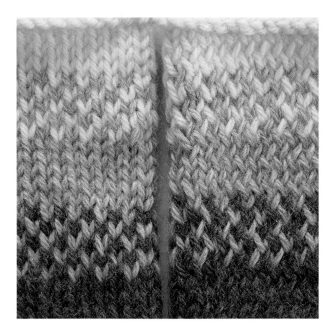

Regular twined stockinette stitch on the left and zigzag stitch on the right

If you look at the inside of the work, you can see if you have twisted the strands over or under. The twined knit-over stitches look like right-leaning slashes and the twined knit-under stitches look like left-leaning slashes.

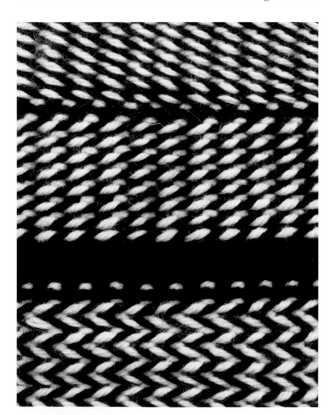

The section on the top shows the wrong side of twined knitting with the back strand going *under* the front strand. The section in the middle shows the wrong side of traditional twined knitting (back strand twisted *over* front strand). The bottom section shows the wrong side of zigzag knitting.

When twined stockinette stitch is knit back and forth instead of in the round, a zigzag pattern is created simply by making the standard twined knit and reverse purl stitches (the back strand brought *over* front strand for a knit stitch and *over* the front strand for a purl stitch). This is the technique I used to make the scarves on page 41.

Sometimes you may want to add a row of purl stitches for texture. If you are knitting in the round and you twine the purl stitches by bringing the back strand *over* the front strand instead of under, the strands will also untwist. This won't create a noticeable zigzag, but it does make the knitting a little easier.

CROOK STITCH

The traditional crook stitch is a purl 1, knit 1, purl 1 combination, in which the two strands are not twisted. Although I've varied this in several of the patterns, the basics are still the same.

1. Bring the next strand to be knit (the back strand) to the front of the work.

2. Purl one stitch with this strand.

3. Keep the purl strand in front of your work and knit one stitch with the strand held at the back of the work. Purl one more stitch with the front strand.

4. Return the front strand to the back. If continuing with a larger variation of the crook stitch, keep the strand to the front.

5. Repeat steps 2–4 to the end of the round or row or as indicated.

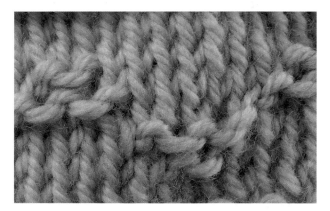

Crook-stitch pattern

JOGLESS INTERSECTIONS

When you knit different patterns in the round, there ends up being a jog at the beginning of a round in the new pattern. To eliminate this, at a pattern change, slip the first stitch of the new pattern round purlwise. In the next round twine knit or twine purl, according to the pattern, into the slipped stitch.

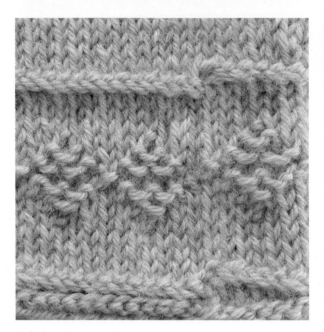
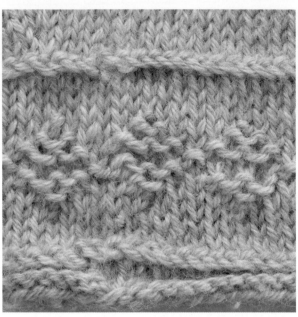

The visible jog in the pattern on the left can be smoothed by slipping the first pattern stitch as in the example on the right.

CHAIN-STITCH PATH

In a knit 1, purl 1 chain stitch, the strand used to purl is carried at the front of the work, and the strand used to knit is carried at the back. The strands of yarn are not twisted. A chain-stitch "path" is created when two or more rounds of chain stitch are offset so the stitches knit in the first round are purled in the second. If you are working in the round, it is simplest to have an odd number of stitches to make a chain-stitch path. If you have an even number of stitches, there will have to be either two knit stitches or two purl stitches side by side at the end of each round.

For a chain-stitch path worked on an odd number of stitches:

1. Bring the strand to be purled to the front of the work. Purl one stitch with this strand and, keeping the purl strand at the front, knit one stitch with the strand positioned on the back of the work. Keeping the strands in their positions, alternate purl and knit stitches for one round.

2. On the second round, keep the strands in their places and knit into the purl stitches and purl into the knit stitches.

A chain-stitch path adds attractive texture to a project.

STRANDED KNITTING AND YARN DOMINANCE

For two-color knitting where stretch and flexibility are not as necessary, you may prefer to use a stranded method like Fair Isle instead of twining. In two-handed Fair Isle, one color strand is held in the right hand and knit in the English or "throwing" style. The other color strand is held in the left hand and knit with the Continental or "picking" method. I combine the two-handed Fair Isle technique with twining in the Flower-Border Bag on page 89.

1. Hold one color strand (main color for these instructions) in your right hand and the other color in your left.

Main color is in the right hand and contrast color is in the left.

2. Knit and purl all main-color stitches using the throwing method.

3. To make a contrast-color knit stitch with the picking method, insert the right needle into the first stitch on the left needle as if to knit. Lay the contrast yarn over the tip of the right needle as shown.

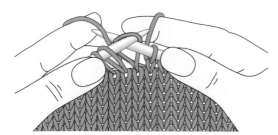

Lay the contrast color over the right needle.

4. Bring the right needle through the left-hand stitch, scooping up the contrast strand.

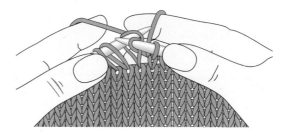

Scoop up the strand as you bring the needle through the stitch.

5. Drop the stitch off the left needle.

It takes a little practice to get even tension with the main- and contrast-color yarns. But even if your tension is perfect, one yarn will still appear more dominant than the other. This is because of the way the yarns are knit. The yarn held in your left hand will be the more dominant one. If you look closely when you take a stitch with the left-hand strand, you can see it is carried in front of and beneath the other strand. The yarn thrown with your right hand is brought from behind and lifted over the other strand. It will appear less dominant. Because of this it is very important that you consistently hold the color you want to be dominant in your left hand and hold the less-dominant color in your right. Keep the yarn balls in the desired order; dominant color to the left and less dominant color to the right. This will help you remember which yarn is dominant and also keep the yarns from twisting.

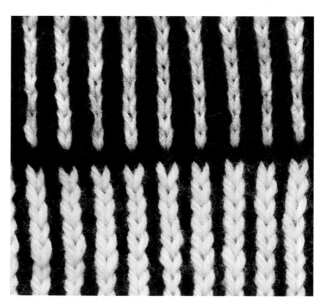

The stitches are identical except in the top version the black yarn is held in the left hand and appears dominant. In the bottom version the white yarn is held in the left hand and appears dominant.

THREE-STRAND KNITTING

Have you tried two-handed Fair Isle from the previous section? Combining this technique with twined knitting is how I made the Holly-Leaves-and-Berries pattern for the hat shown above (see page 83 for instructions). The red main-color background is twine knit from two strands held in your right hand and the white pattern stitches are stranded with your left hand. The 3-strand result is wonderfully thick and warm but does not have quite the stretch of regular twined knitting.

Twining the two main-color strands is the same as simple twining. The two strands alternate with every stitch, bringing the back strand over the front strand. The contrast color is made with one strand and is not twined, but held in the left hand, carried along, and knit with the picking method.

1. Hold the two main-color twining strands in your right hand and the strand of contrast color in your left. Follow the project pattern and twine stitch the main color, alternating the two yarns.

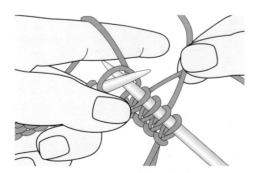

Work twining strands with your right hand and contrast-color strand with your left.

2. To make contrast-color knit stitches, follow steps 3–5 of "Stranded Knitting and Yarn Dominance" on page 27 and knit the stitches with the picking method. Do not twine the contrast strand with the main-color strands and be careful not to pull these stitches too tight.

3. Continue knitting in this manner, twining the two main-color strands with your right hand and picking the contrast-color strand with your left hand, according to the pattern.

Anchoring Contrast-Color Strand

If the contrast-color strand has to be "floated," or carried over more than two stitches, it needs to be woven through a main-color strand on the wrong side of the work. (Because the main-color strands are twined, they do not need to be anchored in these projects.)

1. To anchor the contrast-color strand behind a main-color stitch, insert the right needle tip into the next stitch to be knit. Wrap the contrast-color strand over the top of the needle clockwise.

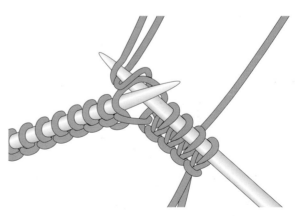

Wrap the contrast-color strand clockwise.

2. Wrap the main-color strand to be knit around the needle counterclockwise.

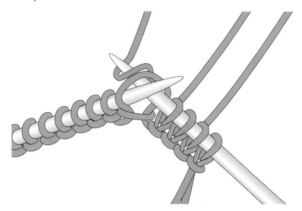

Wrap the main-color strand counterclockwise.

3. Unwrap the contrast strand from the right needle and return it to the back of the work.

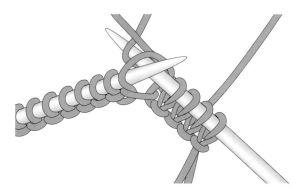

Unwrap contrast strand and hold to back of work.

4. Complete the stitch with the main-color yarn. The contrast strand is caught behind the main-color stitch.

SHORT ROWS

Rather than knitting a gusset, I like to shape the heel of my socks with short rows.

Knit-Stitch Short Rows

With twined knitting there are two strands to work, but the basic technique is the same as for short rows in regular knitting.

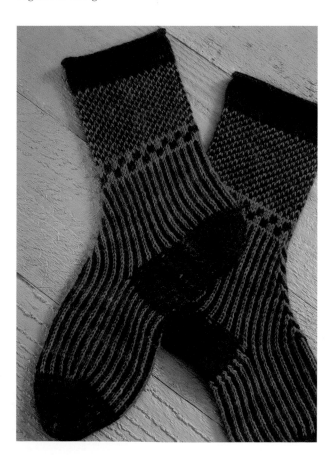

1. Divide the stitches on the needles as indicated on the pattern. Twine knit across until two stitches remain. Bring the next strand of yarn to be knit to the front of the work. Slip the next stitch purlwise from the left needle to the right.

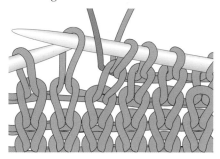

Bring strand to be knit to front.
Slip next stitch from left to right needle.

2. Move the strand to the back of the work and slip the stitch back to the left needle. The slipped stitch is wrapped, but not knit or purled. Turn, place a marker, and starting with the strand that wrapped the stitch, twine purl back across the row.

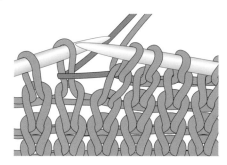

Bring strand to back.
Slip stitch back to left needle.

3. After the shaping is complete and you knit across the row, you will knit the wrapped stitches and the wrapping loops together. Lift the wrap loop and place it on the left needle over and to the left of the stitch it wrapped. Knit the stitch and the wrap loop together through the back of the stitch and the loop.

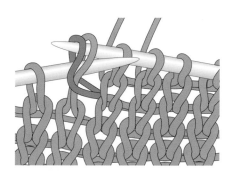

Lift the wrap and place it to the left of the stitch on the needle; knit stitch and wrap together through the back loops.

Purl-Stitch Short Rows

Purl-stitch short rows are very similar to knit ones except for the direction of the wrapping strand.

1. Purl across the stitches on the needle until two stitches remain. Bring the next strand of yarn to be purled to the *back* of the work. Slip the next stitch purlwise from the left needle to the right.

2. Bring the strand to the *front* of the work and slip the stitch back to the left needle. The slipped stitch is wrapped, but not knit or purled. Turn the work, place a marker, and starting with the strand that wrapped the stitch, twine knit back across the row.

3. After the initial shaping is complete and you purl across the row, you will purl the wrapped stitches and the wrapping loops together. Lift the wrap loop from the knit side and place on the needle over and to the left of the stitch it wrapped. Purl the stitch and the wrap loop together.

I-CORD

I-cord makes terrific handles. You knit it on just two double-pointed needles or use a nifty I-cord machine, the Embellish-Knit!™ (see "Resources" on page 94).

1. With one strand of yarn, cast 4 stitches on a double-pointed needle (sized to the yarn gauge) using your favorite cast on.

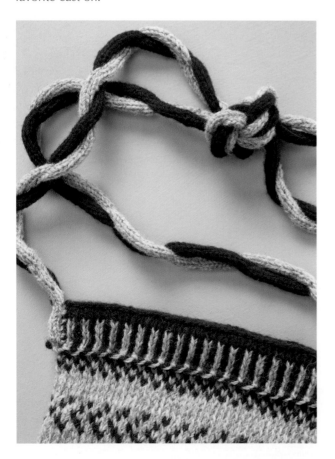

2. Do not turn your work but slide the stitches to the other end of the needle.

3. Knit the 4 stitches, tightening the yarn after the first stitch. Once again, do not turn your work but slide the stitches to the other end of the needle. Knit the stitches, tugging the yarn tight on the first stitch.

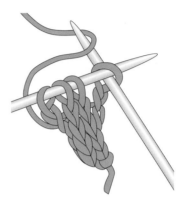

Slide stitches to other end of the needle and knit across. Do not turn work.

4. When the cord is the desired length, bind off all the stitches.

FELTING

Twined knitting felts beautifully, creating a nice, thick fabric. Use 100% wool that is not labeled "machine washable." Some white wools won't felt well, so knit a swatch and test felting your white yarn. You will find a felted project shrinks more in height (row to row) than it does in width (stitch to stitch).

Many front-loading washing machines don't agitate the wool enough to felt it. Felting works best in a top-loading washer. If your project is small, place it in a mesh bag or small pillowcase before putting it in the washer. It sometimes helps to add some old lint-free towels to increase the friction. Use hot water, a low water level, and a small amount of soap. Let your project agitate on the wash cycle for 10–20 minutes. Check the progress of the felting frequently and remove it from the washer when it's felted to the degree you prefer. Rinse thoroughly and spin just for a moment. Spinning too long can cause damage to the project.

You can shape the damp project slightly with a bit of tugging. Dry it slightly stretched over a bowl or other object that is about the right size and shape.

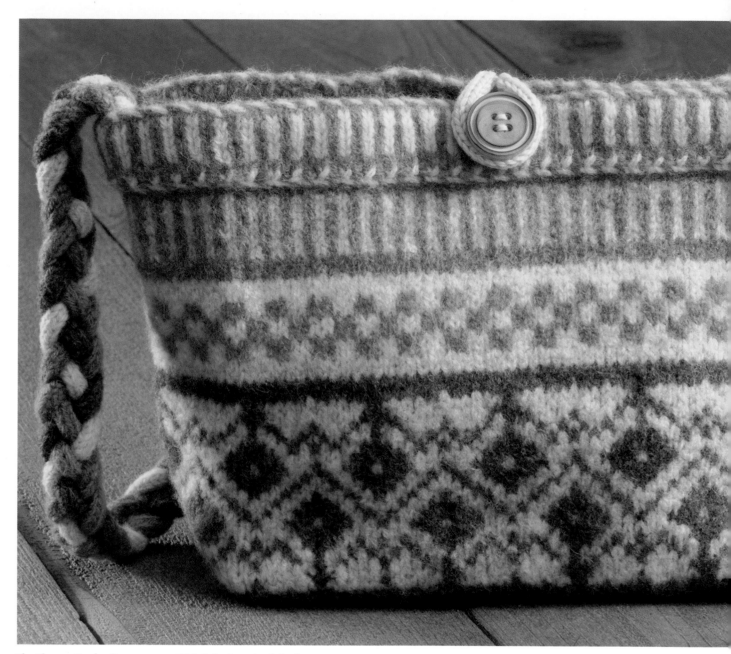

The Flower-Border Bag on page 89 is felted to give it body.

Yarn Weights and Symbols

The following abbreviations and symbols are used in this book.

YARN WEIGHT							
Symbol and Category Name	**0** LACE	**1** SUPER FINE	**2** FINE	**3** LIGHT	**4** MEDIUM	**5** BULKY	**6** SUPER BULKY
Types of Yarn in Category	Fingering 10-count crochet thread	Sock, Fingering, Baby	Sport, Baby	DK, Light Worsted	Worsted, Afghan, Aran	Chunky, Craft, Rug	Bulky, Roving
Knit Gauge Range* in Stockinette Stitch to 4"	33 to 40 sts	27 to 32 sts	23 to 26 sts	21 to 24 sts	16 to 20 sts	12 to 15 sts	6 to 11 sts
Recommended Needle in Metric Size Range	1.5 to 2.25 mm	2.25 to 3.25 mm	3.25 to 3.75 mm	3.75 to 4.5 mm	4.5 to 5.5 mm	5.5 to 8 mm	8 mm and larger
Recommended Needle in U.S. Size Range	000 to 1	1 to 3	3 to 5	5 to 7	7 to 9	9 to 11	11 and larger

These are guidelines only. The above reflect the most commonly used gauges and needle sizes for specific yarn categories.

LEVEL OF DIFFICULTY

If you are fairly new to knitting, I suggest you choose "easy" projects like scarves and hats to get you comfortable with twining. Soon you will be ready for the challenge of the few "experienced"-rated projects.

■□□□ **Beginner:** Projects for first-time knitters using basic knit and purl stitches. Minimal shaping.

■■□□ **Easy:** Projects using basic stitches, repetitive stitch patterns, and simple color changes, shaping, and finishing.

■■■□ **Intermediate:** Projects using a variety of stitches, such as basic cables and lace, simple intarsia, and techniques for double-pointed needles and knitting in the round. Midlevel shaping and finishing.

■■■■ **Experienced:** Projects using advanced techniques and stitches, such as short rows, Fair Isle, more intricate intarsia, cables, lace patterns, and numerous color changes.

Abbreviations

beg.............. begin

BO bind off

CC.............. contrasting color

CO cast on

cont............ continue

dec(s).......... decrease(s)

dpn(s) double-pointed needle(s)

inc(s)........... increase(s)

g................. grams

K knit (regular)

K2tog.......... knit 2 stitches together

LH left hand

M1.............. make 1 stitch

MC............. main color

oz............... ounce

P................. purl (regular)

patt............. pattern

pm.............. place marker

PU.............. pick up and knit

pw.............. purlwise

rem............. remaining

rep(s) repeat(s)(ing)

RH.............. right hand

rnd round

sl slip

sl 1 slip 1 stitch purlwise with yarn in back unless otherwise instructed

sm slip marker

ssk.............. slip, slip, knit

SSTK.......... Slip 1 stitch knitwise, slip 1 stitch knitwise, slip both stitches back to left needle and twine knit

st(s) stitch(es)

tbl............... through back loop(s)

tog.............. together

TK twine knit

TP............... twine purl

TK2tog........ twine knit 2 stitches together

TP2tog........ twine purl 2 stitches together

w&t wrap and turn

yd(s)........... yard(s)

METRIC CONVERSION CHART

m	=	yds	x	0.9144
yds	=	m	x	1.0936
g	=	oz	x	28.35
oz	=	g	x	0.0352

PRACTICE PROJECT:

Media Case or Wrist Warmers

Try this handy little project to learn twined knitting and purling. To turn a wrist warmer into a media case, simply graft the stitches together at one end and add a twisted strap.

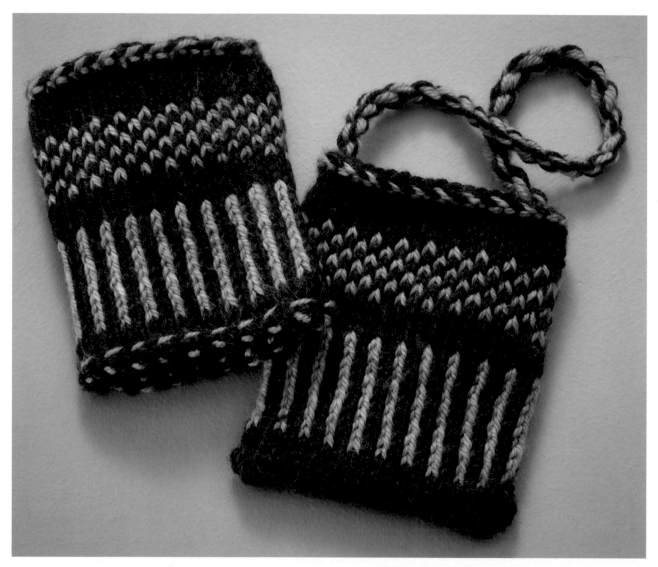

Wrist Warmer (left). Media Case (right).

Skill level: Easy ◖◼☐◗

Size: 4½" x 6¾" circumference

MATERIALS

MC: 1 skein of Aurora 8 from Karabella (100% extra-fine merino wool; 50g; 98 yds) in color 22 dark gray (You will only use approximately 30 yards for the media case and 60 yards for the wrist warmers.) 🎱4

CC: 1 skein of Supersock DK from Cherry Tree Hill (100% superwash merino wool; 4 oz; 340 yds) in color Spring Frost (You will only use approximately 15 yards for the media case and 30 yds for the wrist warmers.) The same yarns are used for the Frosty-Morning collection on pages 65–72. 🎱3

2 US 7 (4.5 mm) circular needles (16" or 24")

Tapestry needle

3 large bobbins (optional)

GAUGE

6 sts and 6 rnds = 1" in twined knitting

INSTRUCTIONS

This project is knit in the rnd from the top down. Wind 2 bobbins or small center-pull balls of MC and 1 of CC.

With 1 strand MC held over thumb and 1 strand CC held over index finger, use "Two-Strand Long-Tail Cast On" method (page 13) to CO 41 sts (not counting slipknot) onto 1 circular needle. Referring to "Two Circular Needles" (page 17), sl 20 sts to 2nd circular needle and carefully remove slipknot. Bring strands to front of work and sl first CO st pw from LH needle to RH needle and beg working in the round, being careful not to twist sts.

Rnd 1: With 1 strand MC and 1 strand CC, *TP1 MC, TP1 CC, rep from * around.
Cut CC strand, leaving 3" tail, join 2nd MC strand.

Rnds 2–5: TP into sl st at beg rnd 2. TK MC around. Set aside or cut 1 MC strand, leaving 3" tail, join CC strand.

Rnds 6, 8, 10: *TK1 MC, TK1 CC, rep from * around.

Rnds 7, 9, 11: *TK1 CC, TK1 MC, rep from * around; at end of rnd 11, K2tog—40sts.
Cut CC strand, leaving 3" tail, join 2nd MC strand.

Rnds 12–15: TK MC around.
Cut 1 MC strand, leaving 3" tail, join CC strand.

Rnds 16–25: *TK1 MC, TK1 CC, rep from * around for 10 rnds of stripe patt.
Set aside CC strand, join 2nd MC strand.

Rnds 26–29: TK MC around.

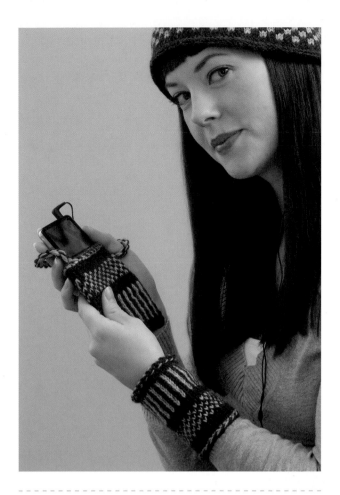

FINISHING

Media case: Cut 1 strand with 3" tail and 2nd strand with 20" tail. Use longer tail and Kitchener stitch (page 24) to graft sts tog. Weave in ends.

Media case strap: Cut one 36" strand of each color. Tie one end of strand ends tog with overhand knot. Rep with other end. Secure one end of knotted strands to a doorknob, or pin to heavy object. Twist strands until cord begins to fold back on itself. Fold in half. Hold both ends and shake to even out the twists. Use MC yarn and tapestry needle to sew each end to inside of an upper corner of the case.

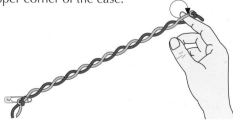

Twist the yarn until it kinks.

Wrist warmer: Rnd 30: *TP MC, TP CC, rep from * around. Cut 1 MC strand, leaving 25" tail. Cut rem strands, leaving 3" tails. Use the long tail to BO all sts using "Sewn Bind Off" (page 23). Weave in ends. Make second matching wrist warmer.

Blue-and-White Striped Neck Gaiter

Here's a very easy project to practice twined knitting in the round. The pattern is quick to knit with great results. This yarn is incredibly soft because it's lightly spun, creating an airy, feathery feel.

Skill level: Easy ◖■☐▭

Size: 8" x 19½" circumference

MATERIALS

Baby Alpaca Chunky by Cascade Yarns (100% baby alpaca; 100g; 108 yds) **⑤**

MC: 1 skein in color 559 light blue

CC: 1 skein in color 565 off-white

1 US 10 (6 mm) circular needle (16")

Tapestry needle

2 large bobbins (optional)

GAUGE

18 sts and 18 rnds = 4" in twined knitting

INSTRUCTIONS

With 1 strand MC held over thumb and 1 strand CC held over index finger and using the "Twisted German Cast On" (page 14), CO 88 sts (not counting slipknot). Remove slipknot and sl first st pw from LH needle to RH needle and beg working in the rnd, being careful not to twist sts. Tighten loose loops.

All rnds: *TK1 MC, TK1 CC, rep from * around . At beg rnd 2, TK into sl st with color that maintains stripe patt, always knit with same color strand as st being knit in (on row below), creating stripe patt.

Work for a total of 8" or as desired. BO with MC using "Sewn Bind Off" (page 23). Use tapestry needle to weave in ends so they don't show on rolled edges.

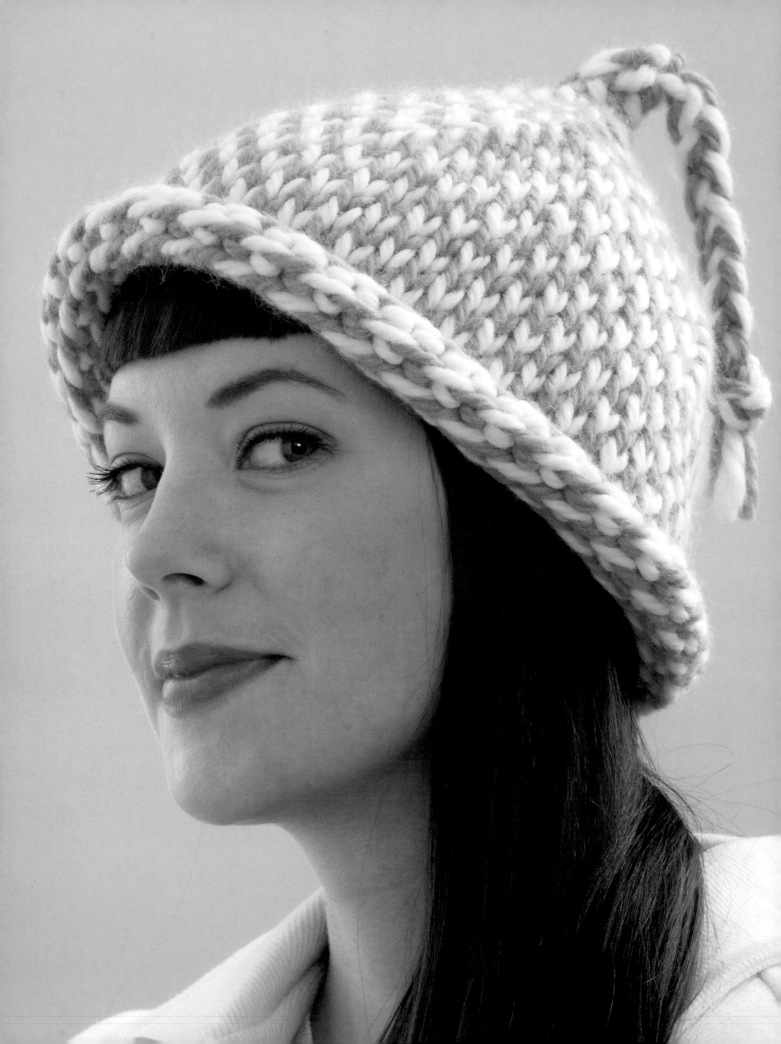

Basic Blue-and-White Checked Hat

Here's another easy project that the young and young at heart will love. The yarn I used is thick and lightly spun, creating a lightweight but warm hat. One skein each of the blue and white yarns is sufficient to knit both the checked hat and the alternate "Striped Hat Variation" on page 40.

Skill level: Easy ◖■☐◗

Size: Child (Adult Medium, Adult Large)

Circumference: 17¾ (20½, 22)"

MATERIALS

Lana Grande from Cascade Yarns (100% Peruvian wool; 100g; 87 yds) **6**

MC: 1 skein in color 6025 blue

CC: 1 skein in color 6010 cream

2 US 15 (10 mm) circular needles (16")

Tapestry needle

4 stitch markers to fit size 15 needles

GAUGE

11 sts and 12 rnds = 4" in twined knitting

CHECK PATTERN (ODD NUMBER STS)

Work with 1 strand MC and 1 strand CC. Make st with different color than st being knit into (on row below).

Rnd 1: TK1 MC, *TK1 CC, TK1 MC, rep from * around.

Rnd 2: TK1 CC, *TK1 MC, TK1 CC, rep from * around.

This project is worked in the round from brim to crown.

BRIM

With 1 strand MC held over thumb and 1 strand CC held over index finger, use "Two-Strand Long-Tail Cast On" method (page 13) to CO 49 (57, 61) sts (not counting slipknot). Remove slipknot. Sl first st pw from LH needle to RH needle and beg working in the rnd, being careful not to twist sts. Tighten loose loops.

Rnds 1–12: Work in check patt. At beg rnd 2, TK into sl st with color that maintains patt, otherwise work in check patt around until last 2 sts of rnd 12, TK2tog—48 (56, 60) sts.

CROWN

The decs cause 2 side-by-side same-color sts. These will be dec tog in the next rnd, reestablishing patt. Except at decs, knit into each st with different color; blue into white, white into blue.

Rnd 1: *TK10 (12, 13) in check patt, SSTK, pm, rep from * to end of rnd—44 (52, 56) sts divided in 4 sections.

Rnd 2: *TK in check patt until 2 sts before marker. SSTK with strand that maintains stripe patt, sm, rep from * to end of rnd—40 (48, 52) sts.

Rep rnd 2 until 8 sts rem, switching to 2 circular needles when too few sts for 1 needle.

Final rnd: TK2tog around—4 sts rem.

FINISHING

Cut strands, leaving 6" tails. Thread tails on tapestry needle and pull yarn tails through sts. Snug up tight and remove tapestry needle. Cut one 12" strand of each yarn. Fold both strands in half to determine the middle. Center strands over top center of hat. Knot knitting yarn tails over middle of 12" strands. Pair MC strands with CC strands in 3 groups; braid 3 groups tog. Tie ends with overhand knot and trim raw ends. Weave in CO ends so they don't show on rolled edge.

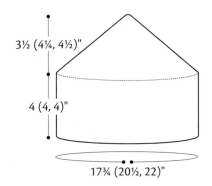

3½ (4¼, 4½)"

4 (4, 4)"

17¾ (20½, 22)"

Striped Hat Variation

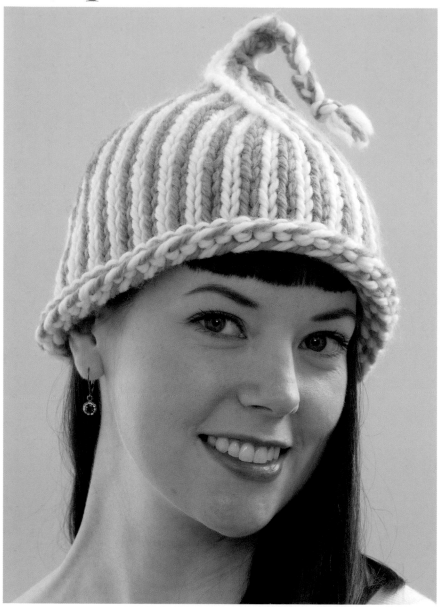

Just as easy as the checked version, this striped hat knits up quickly! This pattern is very similar to the checked version, but knitting an even number of stitches each round instead of an odd number creates stripes. Use the leftover yarn from the checked version.

Work as for the Basic Blue-and-White Checked Hat except as follows:

STRIPE PATTERN (EVEN NUMBER STS)

Knit into st with same color: blue into blue, white into white.

*TK1 MC, TK1 CC, rep from * around.

BRIM

CO 48 (56, 60) sts. Sl 1 st pw and beg working in the rnd.

Rnds 1–12: Work in stripe patt.

At end of rnd 12, skip TK2tog step.

CROWN

Divide sts and dec following instructions for checked version.

Three Tweedy Scarves

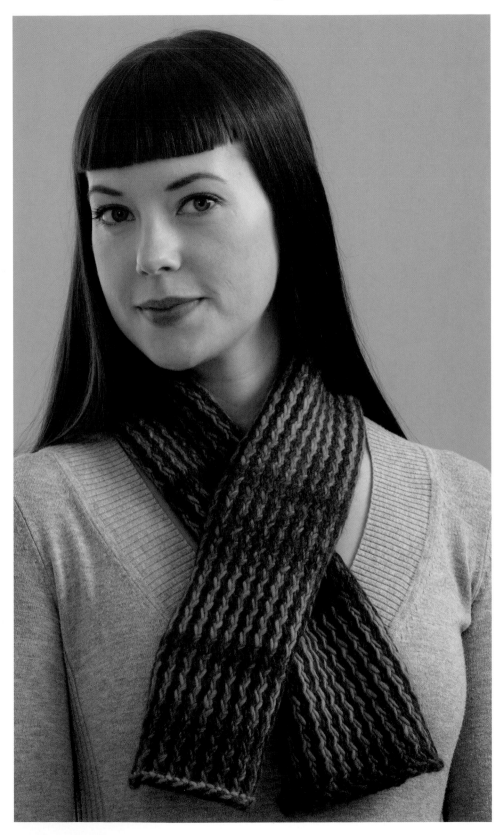

Scarf knit in Saddle Brown and Copper Silk

Historically, twined knitting means knitting in the round. This scarf, knit back and forth on straight needles, successfully challenges that notion. It's a wonderful project to practice both twined knitting and purling, and you'll find it's quick and easy to make. The zigzag-stitch texture results from twining the purl rows by bringing the back strand *over* instead of *under* the front strand. The stitches untwist every row, making it easy to knit and visually interesting on both sides. Using a variegated yarn and a solid color adds wonderful depth.

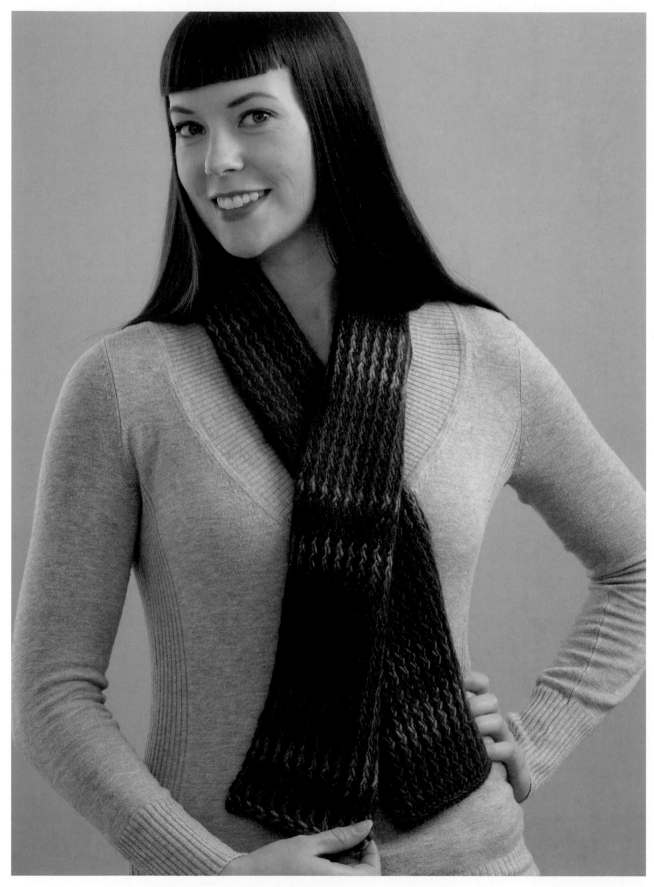

**Variation A made with Peruvia from Berroco in color 7148 Boysenberry
and Jasper from Berroco in color 3833 Verde Lavras**

Skill level: Easy ◖▮☐☐

Size: 5¾" x 38½"

Variation A: 4½" x 50"

Variation B: 3¼" x 90"

MATERIALS

MC: 1 skein of Peruvia from Berroco (100% Peruvian wool; 100g; 174 yds) in color 7152 Saddle Brown (**4**)

CC: 1 skein of Jasper from Berroco (100% fine merino wool; 50g; 98 yds) in color 3810 Copper Silk (**4**)

US 10½ (6.5 mm) single-pointed needles

Tapestry needle

GAUGE

20 sts and 16 rows = 4" in zigzag twined knitting

INSTRUCTIONS

To create a nice selvage edge, sl first st of all but first two and last two rows pw. When you turn to start new row, be sure to twist MC strand around CC strand before first st. Purl by bringing back strand *over* front strand instead of under as in conventional twine purl st. See "Zigzag Pattern" (page 24). The stripe patt is easy to maintain—always knit with the same-color strand as the st you knit into (MC in MC st, CC in CC st).

With 1 strand MC held over thumb and 1 strand CC held over index finger, use the "Twisted German Cast On" (page 14) to CO 29 sts (not counting slipknot). For variation A, CO 23 sts; for variation B, CO 17 sts.

Rows 1 and 2: Working purl sts by bringing back strand *over* front strand, TP1 MC, *TP1 CC, TP1 MC, rep from * to end; at end of first row do not knit into slipknot. Sl knot off needle, unknot, turn work, and cont with row 2.

Row 3: Sl first st pw, *TK1 CC, TK1 MC, rep from *.

Row 4: Sl first st pw, working purl sts by bringing back strand over front strand, *TP1 CC, TK1 MC, rep from *.

Rep rows 3 and 4 until 48" rem of each yarn, or scarf is desired length.

Last 2 rows: Rep row 2.

BO with MC using "Sewn Bind Off" (page 23). Use tapestry needle to weave in ends. Block with mist and/or steam to flatten.

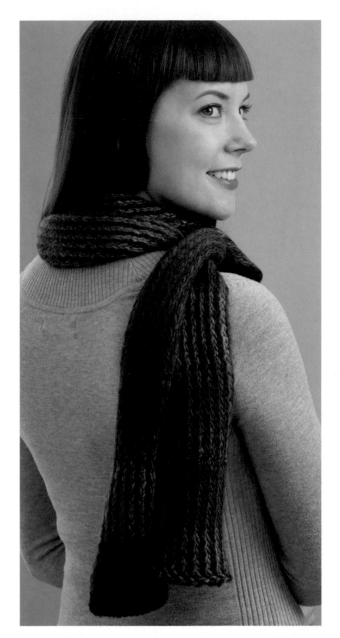

Variation B made with Peruvia from Berroco in color 7152 Saddle Brown and Jasper from Berroco in color 3833 Verde Lavras

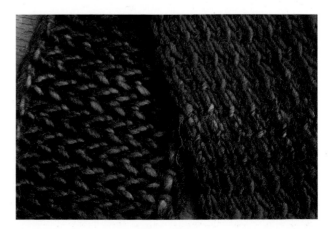

The back shows off the zigzag pattern.

Thick 'n' Thin Brown Hat

Here's an easy project to practice twining. The pattern, which is knit in the round, is quick to knit, and the two different weights of yarn create an interesting texture. The neutral tones make it great for a guy or a gal.

Skill level: Easy ◖■□▭

Size: Child (Adult Medium, Adult Large)

Circumference: 18½ (20½, 22½)"

MATERIALS

MC: 1 skein of Lana Grande from Cascade Yarns (100% Peruvian wool; 100g; 87 yds) in color 6010 cream (6)

CC: 1 skein of Baby Alpaca Chunky from Cascade yarns (100% baby alpaca; 100g; 108 yds) in color 565 beige (5)

2 US 15 (10 mm) circular needles (16")

6 stitch markers to fit needles

Tapestry needle

GAUGE

12 sts and 14 rnds = 4" in twined knitting

STITCH PATTERNS

Work with 1 strand MC and 1 strand CC.

Stripe (even number sts)

The stripe patt is created by always knitting with same-color strand as st being knit into. (MC into MC st, and CC into CC st.)

*TK1 MC, TK1 CC, rep from * around.

Check (odd number sts)

The check patt is created by always knitting with a different color than st being knit into. (CC into MC st, and MC into CC st.)

Rnd 1: TK1 MC, *TK1 CC, TK1 MC, rep from * around.
Rnd 2: TK1 CC, *TK1 MC, TK1 CC, rep from * around.

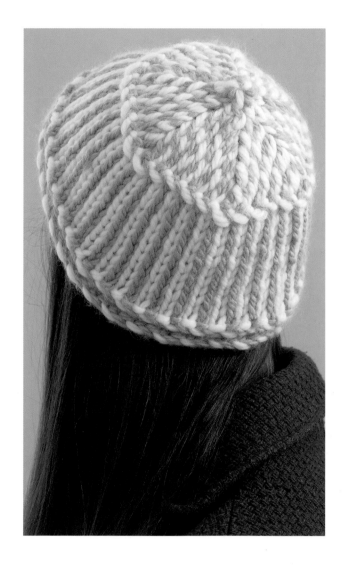

BRIM

With 1 strand MC held over thumb and 1 strand CC held over index finger and using "Two-Strand Long-Tail Cast On" (page 13), CO 56 (62, 68) sts (not counting slipknot). Remove slipknot and sl first st pw from LH needle to RH needle and beg working in the round, being careful not to twist sts. Tighten loose loops.

Rnds 1–3: Work around in stripe patt.

Rnd 4: Sl 1 st pw, TP1 CC, *TP1 MC, TP1 CC, rep from * around.

Rnd 5: TP MC into sl st, TK1 CC, *TK1 MC, TK1 CC, rep from * around in stripe patt.

Rnds 6–15: Work around in stripe patt.

Rnd 16: Sl first st pw, TP1 CC, *TP1 MC, TP1 CC, rep from * until 2 sts rem, TP2tog—55 (61, 67) sts.

Rnd 17: TP CC into sl st, TK1 MC, *TK1 CC, TK1 MC, rep from * around, working in check patt.

Rnd 18: Work around in check patt.

Rnd 19: Work around in check patt until 2 sts rem, SSTK—54 (60, 66) sts.

CROWN

... t maintains check patt.
... en project is too small

...K, pm, rep from *
...d into 6 equal sections.

... 2 sts before marker,
...0 (36, 42) sts.

Rep rnds 2 and 3 until 6 (12, 6) sts rem.

Next rnd (Adult Medium only): *TK2tog, SSTK, rep from * around—6 sts.

Final rnd (all sizes): *TK1 MC, TK1 CC, rep from * around, remove markers.

Cut strands, leaving 6" tails. Thread on tapestry needle and pull tails through sts. Snug up tight and weave in ends.

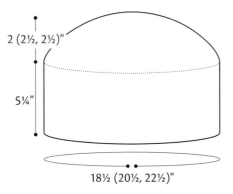

2 (2½, 2½)"

5¼"

18½ (20½, 22½)"

Drawstring Tote and Hat in Variegated Yarns

Felt this project to make a purse or leave it unfelted for a very cute hat. You will have enough yarn to make both for a matching set.

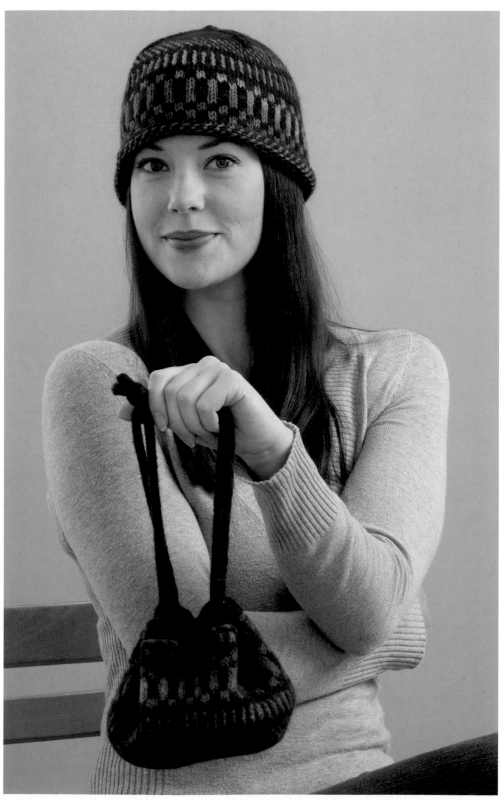

Skill level: Intermediate ◖■■▢

Size: Child (Adult)

Hat: 16½ (20½)" circumference

Bag after felting: approximately 6" x 17" circumference

MATERIALS

4/8's Wool from Mountain Colors (100% wool; 100g; 250 yds) (🔵4🔵)

MC: 1 skein in color Deep Grape

CC: 1 skein in color Chinook

2 US 8 (5 mm) circular needles (16")

Tapestry needle

12 straight pins for purse

Sewing needle and matching thread for purse

3 large bobbins (optional)

GAUGE

24 sts and 24 rnds = 4" in twined knitting

STITCH PATTERNS

Work with 1 strand MC and 1 strand CC. In large check and large stripe patts, do not twine between two consecutive stitches made with the same color. Only twine strands between two stitches made with different colors.

Large Check (multiple of 4 sts)

Rnds 1 and 2: *K2 MC, twine strands, K2 CC, twine strands, rep from * around.

Rnds 3 and 4: *K2 CC, twine strands, K2 MC, twine strands, rep from * around.

Large Stripe (multiple of 4 sts)

All rnds: *K2 MC, twine strands, K2 CC, twine strands, rep from * around.

Small Stripe (even number sts)

All rnds: *TK1 MC, TK1 CC, rep from * around.

Small Check (odd number sts)

Rnd 1: TK1 MC, *TK1 CC, TK1 MC, rep from * around.

Rnd 2: TK1 CC, *TK1 MC, TK1 CC, rep from * around.

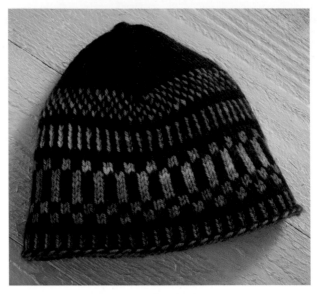

I like the secondary patterns that form when using a variegated yarn with a solid.

These projects are worked in the round. If you use large bobbins, wind two of MC and one of CC. To make the bag, follow instructions for Adult-sized hat.

BRIM

With 1 strand CC held over thumb and 1 strand MC held over index finger, use "Two-Strand Long-Tail Cast On" method (page 13) to CO 100 (124) sts (not counting slipknot) onto 1 circular needle. Remove slipknot and sl first st pw from LH needle to RH and beg working in the rnd, being careful not to twist sts. Tighten loose loops.

Rnd 1: *TP1 MC, TP1 CC, rep from * around.

Rnds 2–5: At beg rnd 2, TP into sl st with color that maintains patt. Work around in small stripe patt.

Rnds 6–7: With 2 strands MC, TK around.

Rnds 8–11: Work in large check patt.

Rnds 12–17: Work in large stripe patt.

Rnds 18–19: Work rnds 3 and 4 of large check patt.

Rnds 20–21: With 2 strands MC, TK around.

Rnds 22–25: Work in small stripe patt.

Rnds 26–27: With 2 strands MC, TK around.

Rnd 28: Sl first st pw, work in small check patt to st before sl st; TK2tog MC—99 (123) sts.

Rnds 29–32: Cont in small check patt.

CROWN

Rnd 1: With 2 strands MC, TK24 (30), pm, *TK 25 (31), pm, rep from * around.

Rnd 2: TK until 2 sts before marker. SSTK, sm, *TK2tog, TK until 2 sts before marker, SSTK, sm, rep from * around—92 (116) sts.

Rnd 3: *K2tog, TK until 2 sts before marker, SSTK, sm, rep from * around—84 (108) sts.

Rep rnd 3, switching to 2 circular needles when too few sts for 1 needle, until 12 sts rem.

Final rnd: *TK2tog, SSTK, rep from * around—6 sts.

Cut strands, leaving 6" tails. Use tapestry needle to thread strands through rem sts, tighten, and bring ends to inside of hat. Weave in ends. For bag, follow finishing instructions below.

FINISHING

Measure top edge circumference before felting. Use MC to make 3 times this number plus 12" of 4-st I-cord, referring to "I-cord" (page 30). **For example:** The top edge measures 20" around. Three times 20" = 60" plus 12" = 72". You would need 72" of I-cord.

Place I-cord in mesh bag or small pillowcase. Felt bag and I-cord. Block bag on a form or bowl and hang I-cord to dry. After felting and drying, cut one piece of I-cord same length as felted circumference at top of bag. Sew it end-to-end, making a circle. Cut rem I-cord evenly in half for drawstrings.

To divide top edge of bag into 12 equal sections, first divide in quarters; then each quarter in thirds. Place 1 straight pin to mark each section.

Use sewing needle and matching thread to securely tack circle of I-cord to top edge of bag at each pin mark.

Pull one I-cord strand through loops formed between the tacking sts on top edge. Knot cord ends tog. Pull rem I-cord strand opposite direction through loops. Knot cord ends tog.

2 (2½)"

5¼"

16½ (20½)"

I-cord loops on the top of the bag hold the drawstring.

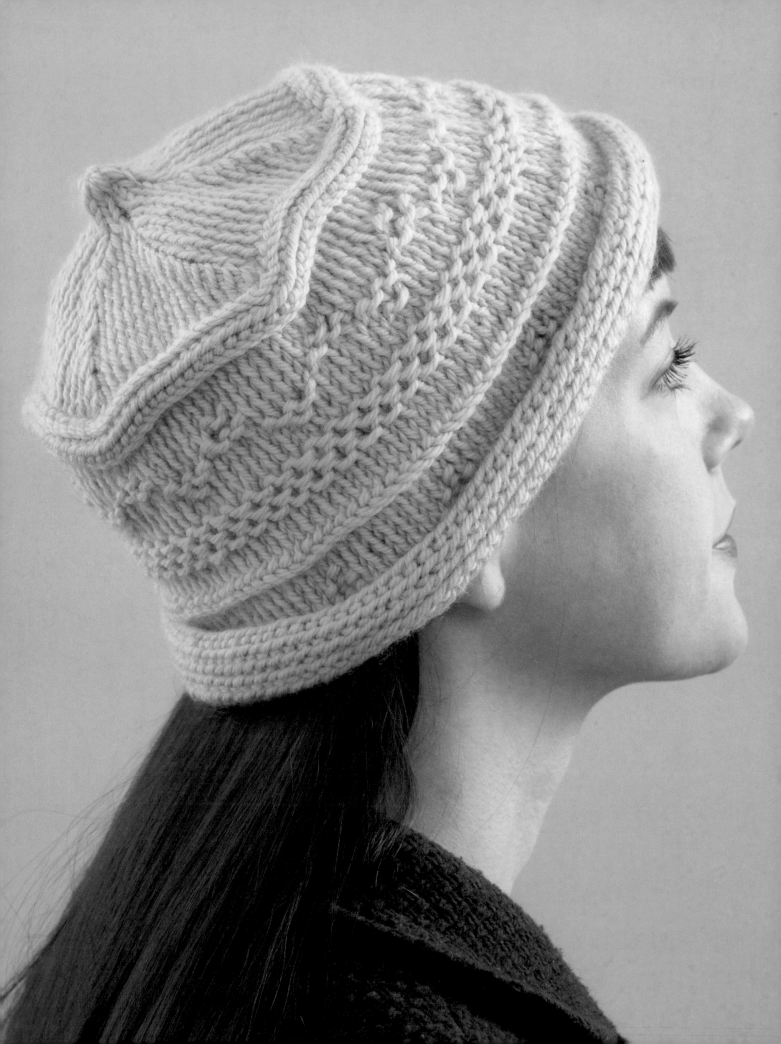

Traditional Textured Hat

Tradition meets modern when patterns of the past are worked in today's superwash wool. Textures pop out all over when you use these easy-to-knit stitches. Pair this hat with the "Traditional Mittens" on page 76.

Skill level: Intermediate ◼◼◼◻

Size: Child (Adult)

Circumference: 18 (22)"

MATERIALS

2 skeins of 1824 Wool from Mission Falls (100% superwash merino wool; 1.75 oz; 85 yds) in color 002 Stone 🌀❹

2 US 8 (5 mm) circular needles (16")

Tapestry needle

6 stitch markers

2 large bobbins (optional)

GAUGE

20 sts and 20 rnds = 4" in twined knitting

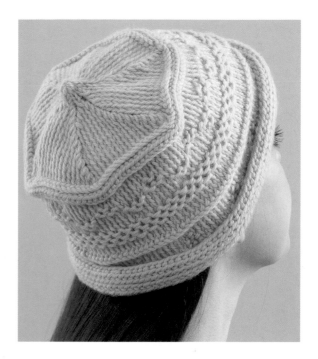

STITCH PATTERNS

To reduce jog between rounds, sl first st pw at beg of each round worked in patt.

Diamond (multiple of 10 sts)

Work purl sts in rnds 2, 3, and 4 a little differently than regular twined purl sts to create a different type of texture. In these rounds, bring strand to be purled to front of work, twining it over last strand, purl st, return strand to back of work; *bring next strand to be worked to front over first strand, purl st, return strand to back*, rep from * for indicated number of sts.

Rnds 1 and 5: *TK7, TP1, TK2, rep from * around.

Rnds 2 and 4: *TK6, TP3 as described above, TK1, rep from * around.

Rnd 3: *TK5, TP5 as described above, rep from * around.

Chain Path (odd number sts)

See "Chain-Stitch Path" (page 26). This K1, P1 patt uses 1 strand for knit sts and the other strand for purl sts. Keep purl strand at front of work and knit strand at back of work throughout rnd. Sts are not twined.

Rnds 1 and 3: P1, *K1, P1, rep from * around.

Rnd 2: K1, *P1, K1, rep from * around.

Crook Stitch (multiple of 10 sts)

See "Crook Stitch" (page 25). Hold purl strand to front of work while keeping rem strand to back of work for knit sts as indicated. Held this way, the 2 strands are not twined. Otherwise, twine knit in normal fashion.

Rnd 1: *TK1, bring next strand to front, P1, K1, P1, bring purl strand to back, TK6, rep from * around.

Rnd 2: *Bring next strand to front, P1, K1, P1, K1, P1, bring purl strand to back, TK5, rep from * around.

Rnd 3: *TK5, bring next strand to front, P1, K1, P1, K1, P1, bring purl strand to back, rep from * around.

Rnd 4: *TK6, bring next strand to front, P1, K1, P1, bring purl strand to back, TK1, rep from * around.

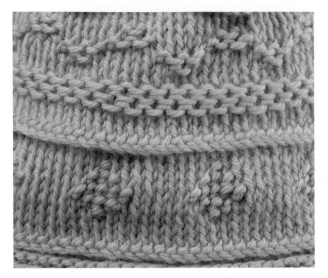

Crook stitch at the top, a three-row chain path below with a purl row, and diamond pattern along the brim

This project is worked in the round from the brim to the crown. Wind yarn on 2 large bobbins or pull 1 strand from each ball. Some purl rows are twined in the opposite direction from regular twine purling, bringing back strand *over* front strand instead of under. This automatically unkinks twists in the yarn from previous row. In addition, twining consecutive purl rows in different directions creates an interesting texture.

BRIM

With 2 strands and using "Two-Strand Long-Tail Cast On" method (page 13), CO 90 (110) sts (not counting slipknot) onto 1 circular needle. Remove slipknot and sl 1 st pw from LH needle to RH needle and beg working in the rnd, being careful not to twist sts. Tighten loose loops.

Rnds 1–5: TK around.

Rnd 6: TP around; twine by bringing back strand over front strand.

Rnds 7–10: TK around.

Rnds 11–15: Work in diamond patt.

Rnds 16–17: TK around.

Rnd 18: TP around; twine by bringing back strand over front strand.

Rnds 19–21: TK around. At end of rnd 21, M1— 91 (111) sts.

Rnds 22–24: Work in chain-path patt.

Rnds 25–27: TK around until 2 sts rem in rnd 27, TP2tog—90 (110) sts.

Rnds 28–31: Work in crook-stitch patt.

Rnds 32–35: TK around.

Rnd 36: TP around; twine by bringing back strand *over* front strand.

Rnd 37: TP around; twine by bringing back strand *under* front strand.

Rnd 38: Rep rnd 36.

CROWN

Snug yarns tight at decs. Switch to 2 circular needles when too few sts for 1 needle.

Rnd 1 (Child size): *TK15, pm, rep from * around—90 sts in 6 equal sections.

Rnd 1 (Adult size): *TK2tog, TK17, pm, TK18, pm, TK18, pm, rep from * around—108 sts in 6 equal sections.

All sizes

Rnd 2: *TK until 2 sts before marker, TK2tog, sm, rep from * around—84 (102) sts.

Rep rnd 1 until 60 sts rem, 4 (7) more times.

Next 4 rnds: *TK2tog, TK until 2 sts before marker, SSTK, sm, rep from * around—12 sts.

Next rnd: TK2tog around, removing markers as you come to them—6 sts.

Final 4 rnds: TK around to form top knot.

Cut strands, leaving 6" tails. With tapestry needle, draw strands through sts and cinch. Weave in ends, hiding well into body of hat as inner edge rolls to outside. Mist and block.

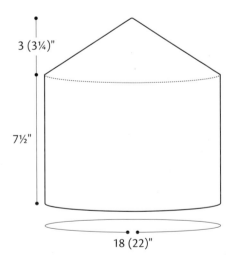

Stitch-Sampler Hat

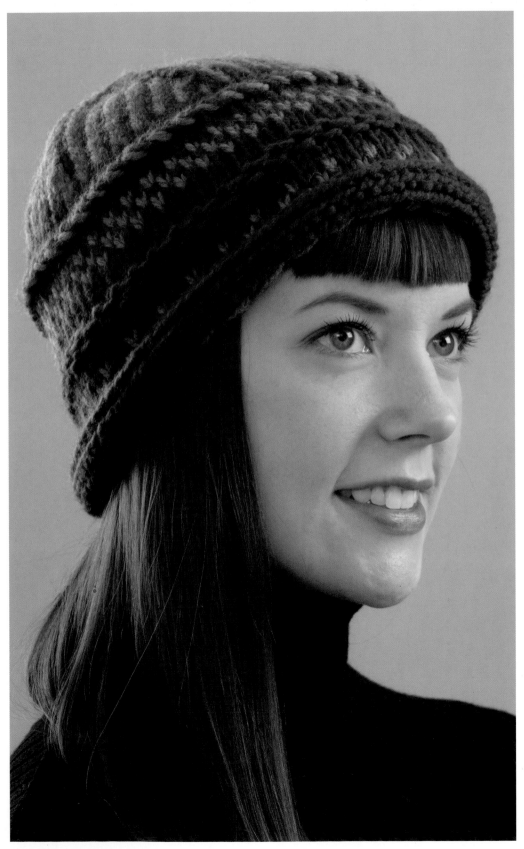

The bulky yarn makes this hat thick and firm—similar to fishermen's hats. There are lots of stitch and color patterns to sample.

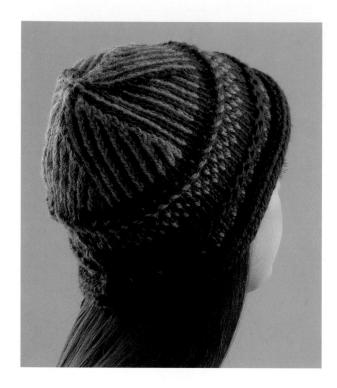

Skill level: Intermediate ◼◼◼◻

Size: Adult

Circumference: 21"

MATERIALS

Cascade 128 from Cascade Yarns (100% Peruvian wool; 100g; 128 yds) **⑤**

MC: 1 skein in color 1183 green

CC: 1 skein in color 8013 taupe

2 US 10 (6 mm) circular needles (16")

Tapestry needle

GAUGE

17 sts and 16 rows = 4" in twined knitting

STITCH PATTERNS

Chevron (multiple of 3 sts)

Work with 1 strand MC and 1 strand CC. See chart on page 55.

Chain Path (odd number sts)

See "Chain-Stitch Path" (page 26). This K1, P1 patt uses 2 MC strands—1 strand for knit sts and 1 strand for purl sts. Keep purl strand at front of work and knit strand at back of work throughout patt. The strands are not twined.

Rnd 1: P1, *K1, P1, rep from * around.

Rnd 2: K1, *P1, K1, rep from * around.

Check (odd number sts)

Work with 1 strand MC and 1 strand CC.

Rnds 1 and 3: TK1 MC, *TK1 CC, TK1 MC, rep from * around.

Rnd 2: TK1 CC, *TK1 MC, TK1 CC, rep from * around.

Stripe (even number sts)

Work with 1 strand MC and 1 strand CC.

*TK1 MC, TK1 CC, rep from * around.

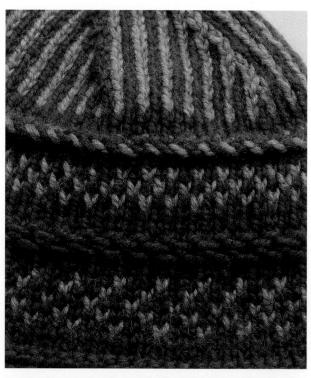

Texture and color combine to make this hat fun to knit and to wear.

This hat is worked in the round from brim to crown. Wind 2 center-pull balls of MC and 1 CC. At beg of pattern changes, slip first st pw. Work last patt st in sl st to avoid jog between rows.

BRIM

With 2 MC strands, one from each ball, and using "Two-Strand Long-Tail Cast On" method (page 13), CO 90 sts (not counting slipknot) onto 1 circular needle. Remove slipknot and sl first st pw from LH needle to RH needle, being careful not to twist sts and beg working in the rnd. Tighten loose loops.

Rnd 1: TK MC around.

Rnd 2: TP MC in sl st. TP MC around.

Rnds 3–5: TK MC around.

Rnds 6–10: Work in chevron patt, following chart at right.

Rnds 11 and 12: TK MC around. At end of rnd 12, M1—91 sts.

Rnds 13 and 14: Work in chain-path patt.

Rnds 15–17: TK MC around.

Rnds 18–20: Work in check patt.

Rnds 21 and 22: TK MC around.

Rnd 23: *TP1 MC, TP1 CC, rep from * around until 2 sts rem, TP2tog—90 sts.

Rnds 24 and 25: TK MC around.

CROWN

On every 2nd dec rnd, 2 same-color sts will be side by side. Knit with same-color strand—next dec rnd sts will be dec tog, reestablishing patt. Switch to 2 circular needles when there are too few sts for 1 needle.

Rnds 1 and 2: Work in stripe patt.

Rnd 3: *Work 15 sts in stripe patt, pm, cont in patt rep from * around.

Rnd 4: *TK in stripe patt until 2 sts before marker, TK2tog, sm, rep from * around—84 sts.

Rep rnd 4 until 6 sts rem.

Cut yarns, leaving 6" tails. Thread tails on tapestry needle and draw through rem sts. Weave in ends and block.

Chevron Pattern
(multiple of 3 sts)

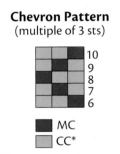

10
9
8
7
6

■ MC
□ CC*

*Do not twine between the 2 CC sts.

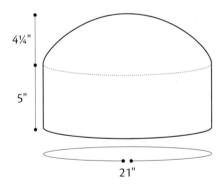

4¼"

5"

21"

Nubby Headband

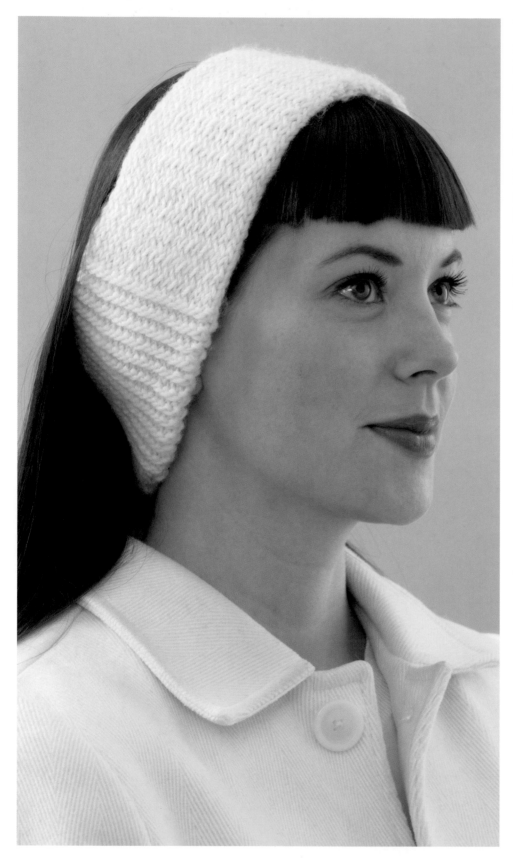

Double thickness makes this headband extra warm, and the soft superwash wool makes it easy to care for. The pattern plays with texture by alternating twined knit and purl rounds and changing the direction of the twist, creating a zigzag effect.

Skill level: Intermediate ◀■■▢

Size: Adult

Circumference: 21"

MATERIALS

1 skein of 220 Superwash from Cascade Yarns (100% superwash wool; 100g; 220 yds) in color 817 off-white **4**

10" length of smooth contrasting waste yarn

2 US 7 (4.5 mm) circular needles (16" or 24")

US 6 to 8 (4 m to 5 mm) straight needle

US 6 to 8 (4 mm to 5 mm) double-pointed needles

Medium-sized crochet hook, US G-6 (4mm)

Tapestry needle

2 large bobbins (optional)

GAUGE

24 sts and 23 rnds = 4" in zigzag twined knitting

This project is worked in the rnd, creating a narrow tube. The ends are grafted together with a seamless join to make the headband. If you prefer to use bobbins, wind 2, refilling as needed. Every rnd is twined in the opposite direction than the round before, creating a zigzag stitch and untwisting the yarn every other rnd (page 24). Weave yarn ends inside tube after a couple of rounds. If you have other yarn ends, weave them in as you go. You will not be able to reach them later.

INSTRUCTIONS

Using "Removable Cast On" (page 14), straight needle, and smooth waste yarn, CO 40 sts. With circular needle and 2 strands of project yarn, TK20, with 2nd circular needle, TK rem 20 sts. Sl first TK st pw from LH needle to RH needle, being careful not to twist sts, and beg working in the rnd. Cinch loops tight.

First Ear Section

Rnd 1: TK around, bringing back strand *over* front strand.

Rnd 2: At beg of initial rnd 2 only, TK into sl st. TP around, bringing back strand *over* front strand. Rep rnds 1 and 2 until section measures 3".

Front Band Section

Rnd 1: TK around, twining in usual manner, bringing back strand *over* front strand.

Rnd 2: TK around, twining by bringing back strand *under* front strand.

Rep rnds 1 and 2 until section measures 11".

Second Ear Section

Rep first ear section.

Back Band Section

Rnd 1: TK around, twining in usual manner, bringing back strand *over* front strand.

Rnd 2: TK around, twining by bringing back strand *under* front strand.

Rep rnds 1 and 2 until section measures 4"—headband should measure 21" in length.

FINISHING

Cut 1 strand of yarn and weave in end to inside of tube. Cut 2nd strand, leaving 30" tail. Sl 20 sts pw to 1 dpn and rem 20 sts to 2nd dpn. Removing waste yarn 1 st at a time, place 20 CO sts on 3rd dpn, and rem 20 CO sts on 4th dpn. Match open ends of tube to make a continuous loop by holding needles with beg and end strands tog. Using 20" yarn tail, tapestry needle, and "Kitchener Stitch" (page 24), graft ends of tube tog snugly. Weave in end to inside of tube.

Clutch Purse

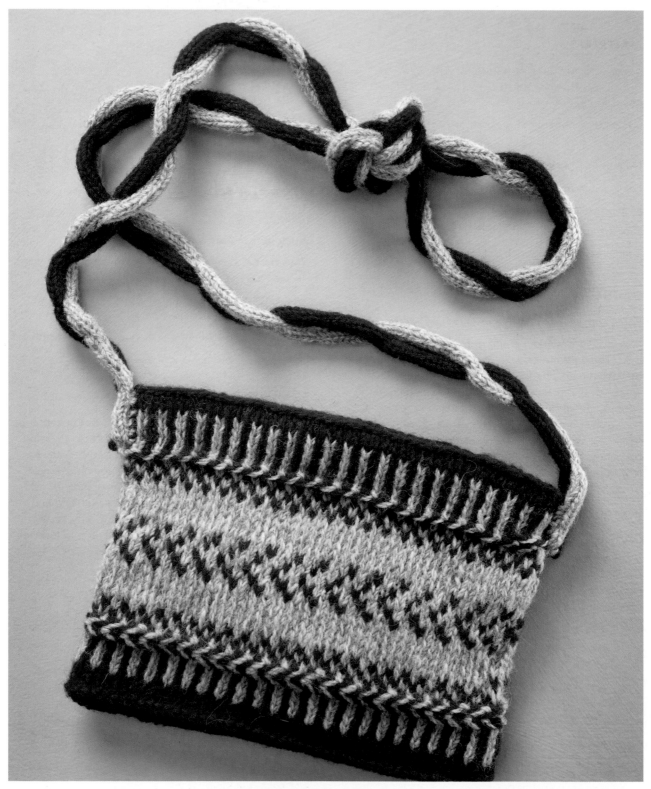

This purse is a handy size for your personal items. The Irish yarn is manufactured with the strands twisted the same way as yarn traditionally used for twined knitting. This forms a firm fabric that does not tend to skew on the bias.

Skill level: Intermediate ◀■■□

Size: 6½" x 16" circumference

MATERIALS

Black Water Abbey (100% Irish wool; 100g; 220 yds) (4)

MC: 1 skein in color Haw

CC: 1 skein in color Silver

Size US 7 (4.5 mm) circular needle (16")

Tapestry needle

10 straight pins

Sewing needle and matching or clear thread

7" polyester zipper

4 large bobbins (optional)

GAUGE

24 sts and 26 rnds = 4" in twined knitting

STITCH PATTERNS

Stripe (even number sts)

Work with 1 strand MC and 1 strand CC.

*TK1 MC, TK1 CC, rep from * around.

Purl Braid (even number sts)

Work with 1 strand MC and 1 strand CC.

Rnd 1: *TP1 MC, twining back strand *over* front strand, TP1 CC, twining back strand *over* front strand, rep from * around.

Rnd 2: *TP1 MC, twining back strand *under* front strand, TP1 CC, twining back strand *under* front strand, rep from * around.

Check (even number sts)

Work with 1 strand MC and 1 strand CC.

Rnd 1: *TK1 MC, TK1 CC, rep from * around.

Rnd 2: *TK1 CC, TK1 MC, rep from * around.

Chevron (see chart on page 60)

Work with 1 strand MC and 1 strand CC. Carry yarn loosely and do not twine strands between 2 sts knit with the same color.

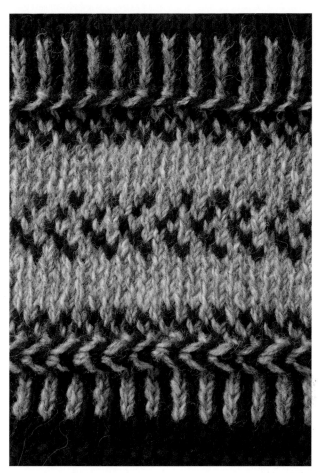

The patterns and textures are reminiscent of classic, traditional twined knitting.

This purse is worked in the round from bottom to top. Sometimes you will knit with 2 strands MC, sometimes 2 strands CC, and sometimes 1 strand of each color. I often "float" the unused strand over the rows instead of cutting it and weaving in ends, but you can cut unused strands to make the untwisting easier. I like to wind 2 large bobbins of each color because it makes switching colors and untwisting easier.

INSTRUCTIONS

Using 2 strands MC and leaving 30" tail on 1 strand for sewing bottom seam, use "Two-Strand Long-Tail Cast On" (page 13) to CO 96 sts (not counting slipknot) onto circular needle. Wind long yarn tail in a small ball and secure to keep it out of the way. Remove slipknot and sl first st pw from LH needle to RH needle, being careful not to twist sts and beg working in the round.

Rnds 1 and 2: With 2 strands MC, TK around.

Rnd 3: Sl first st pw, TP MC around.

Rnd 4: TP into sl st, TK MC around.

Rnd 5: TK MC around.

Rnds 6–10: Work in stripe patt.

Rnds 11 and 12: Work in purl braid patt.

Rnd 13: Work rnd 2 in check patt.

Rnd 14: Work rnd 1 in check patt.

Rnds 15–18: With 2 strands CC, TK around.

Rnds 19–23: Work in chevron patt (chart below).

Rnds 24–27: With 2 strands CC, TK around.

Rnds 28–31: Work in check patt.

Rnd 32: Sl first st pw, *TP1 CC, TP1 MC, rep from * around.

Rnd 33: TP MC in sl st, TK1 CC, cont around in stripe patt.

Rnds 34–37: Work in stripe patt.

Rnds 38 and 39: With 2 strands MC, TK around.

Rnd 40: TP MC around.

Rnds 41 and 42: TK MC around.

Rnds 43 and 44: With 2 strands CC, TK around.

Rnd 45: With 2 strands CC, TP around.

BO with CC using "Sewn Bind Off" (page 23). Cut strands, leaving 1 with 30" tail and 1 with 4" tail.

FINISHING

Flatten bag so beg of rnds are along one side edge. Fold top 5 rows to inside. The purl row (row 40) will be the top edge of bag. Pin folded edge in place. With tapestry needle and 30" yarn tail, sew folded edge to inside of bag, being careful sts do not show on outside.

With 30" CO yarn tail, sew bottom edges tog. Weave in ends and block using steam.

With sewing needle and matching thread, use small stitches to sew zipper to inside of bag, approximately ¼" from top edge.

To make strap, knit 2 I-cords, 1 in each color, measuring 60" long (page 30). Pin 1 end of cords tog; lightly twist. Pin opposite ends tog so cords do not untwist. With sewing needle and matching or clear nylon thread, tack cords tog where they cross each other. Use sewing needle and matching thread to sew each end of strap to top outer corners of bag, placing ends of I-cord even with row 32.

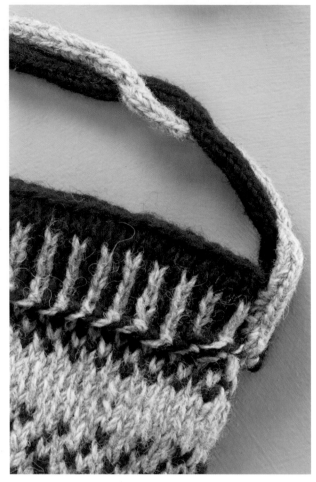

Twist I-cords and tack them together every 3" to 5".

Chevron Pattern
(multiple of 3 sts)

23
22
21
20
19

■ MC
□ CC*

*Do not twine between the 2 CC sts.

6½"

16"

Traditional Swedish Sail Hat

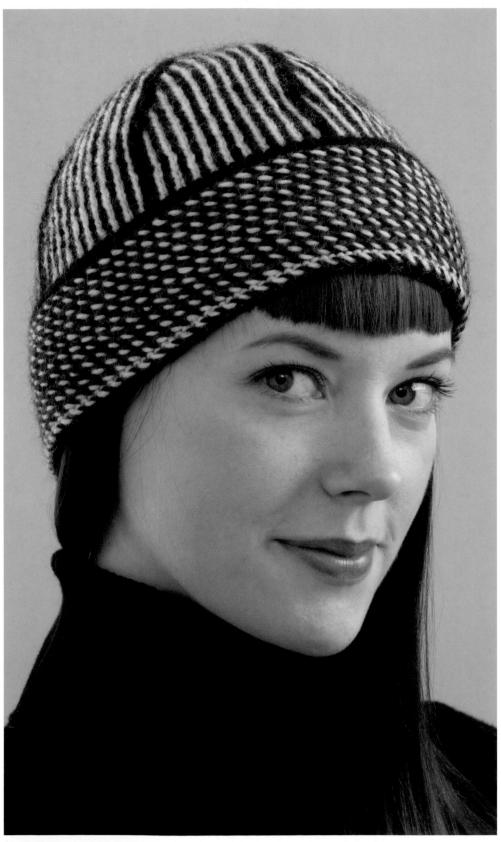

Taken from a Swedish pattern book by Kerstin Jönsson, the traditional Swedish sail hat still holds a modern appeal. This is a very thick fabric which makes it extra warm in the wind. The pattern on the brim is actually very easy! One strand each of black and white are twine purled for a round; then two strands of red are twine knit for a round.

Skill level: Experienced ◼◼◼◗

Size: Adult

Circumference: 20½"

MATERIALS

Istra Kamgarn from Rauma (100% wool; 50g; 120 yds/110m) ②

A: 1 skein in color 2036 Black

B: 1 skein in color 2000 White

C: 1 skein in color 2074 Red

2 US 5 (3.75 mm) circular needles (16")

7 stitch markers

Tapestry needle

4 large bobbins (optional)

GAUGE

28 sts and 26 rnds = 4" in twined knit stitch

STITCH PATTERNS

Black and White with Red Stripe (multiple of 2 sts)

Use 1 strand each of A and B and 2 strands of C. At end of rnd 1, let A and B strands dangle at front of work while twine knitting with 2 C strands at back of work. At end of rnd 2, let C strands dangle at back of work while twine purling with A and B strands on front. Red strands do not twine with black and white strands.

Rnd 1: *TP1 A, TP1 B, rep from * around. At end of rnd, leave A and B strands at front of work.

Rnd 2: With 2 strands of C held at back of work, TK around. At end of rnd, leave C strands at back of work.

Bordered Stripe (multiple of 21 sts)

Work with 1 strand A and 1 strand B.

TK1 A, *TK1 B, TK1 A, rep from * 9 more times.

Rep patt around.

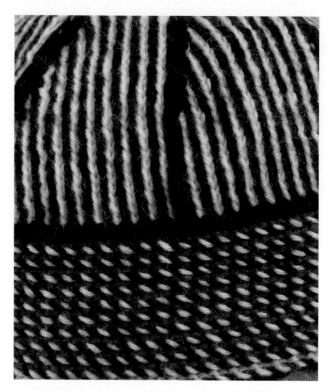

A round of twined purl stitch in black and white alternates with a round of twined knit red stitches.

This hat is worked in the round from brim to crown. I like to wind yarn on bobbins because it makes untwisting easier, especially when working with three colors. Wind two large bobbins of red, one of black, and one of white—refill as needed.

BRIM

Use the "Twisted German Cast On" method (page 14), running strand A over thumb and strand B over index finger, and CO 146 sts not counting slipknot. Remove slipknot and sl first st pw from LH needle to RH needle, being careful not to twist sts and beg working in the round. Tighten loops.

Rnd 1: *TP1 A, TP1 B, rep from * around, keeping both A and B strands at front of work.

Rnd 2: TP in sl st. With 2 strands of C, TK around, keeping both C strands at back of work.

Rnds 3–22: Work in black and white with red stripe patt.

Cut C strands, leaving 4" tails. Bring B strand to back of work.

Rnd 23: With 2 strands A, TK around, M1—147 sts.

Rnd 24: With 2 strands A, TP around.

CROWN

The number of TK1 B, TK1 A reps in each section of border stripe patt will change due to decs. Maintain stripe patt by TK with same-color strand as st being knit into. Switch to 2 circular needles when too small to knit with 1.

Rnd 1: *Work bordered stripe patt, pm, rep from * around to divide into 7 sections, each with 21 sts—147 sts total.

Rnds 2–13: *Work bordered stripe patt, sm, rep from * around.

Rnd 14: *Work in bordered stripe patt to 2 sts before marker, TK2tog, sm (there are 3 A sts side by side), rep from * around—140 sts.

Rnd 15: Rep rnd 14 (there are 2 A sts side by side)—133 sts.

Rnd 16: Work even in border stripe patt, adjusting number of TK1 B, TK1 A reps as needed to maintain stripes.

Rnds 17–25: Rep rnds 14–16—91 sts at end of rnd 25.

Rnds 26–36: Rep rnds 14 and 15—14 A sts at end of rnd 36.

Rnd 37: With one strand A, K2tog to end of rnd.

Cut strands, leaving 6" tails. With tapestry needle, pull yarn tails through rem sts and cinch loops. Weave in ends.

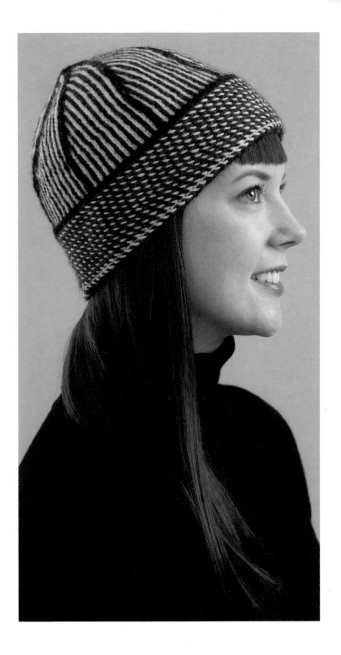

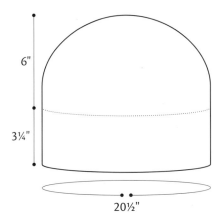

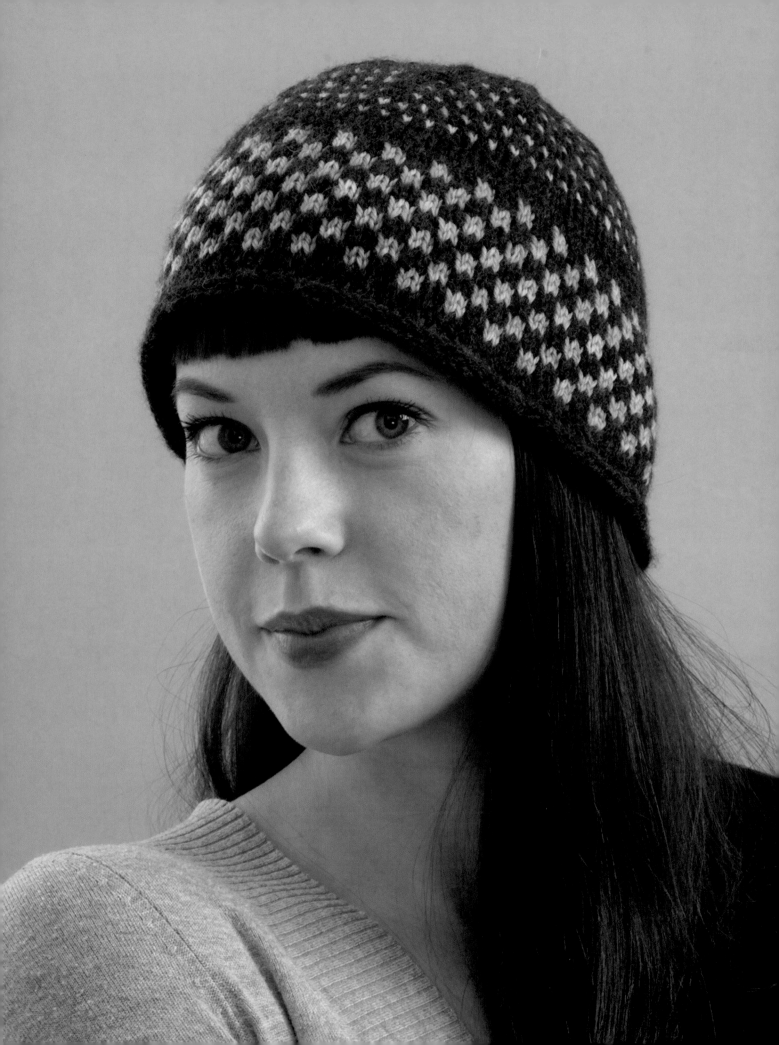

Frosty-Morning Hat

Wear this warm hat on a frosty morning with your coordinating Frosty-Morning Mittens (page 67) and Frosty-Morning Socks (page 70). One skein of Supersock and five skeins of Aurora 8 will be enough to make all three projects plus the Media Case or Wrist Warmers (page 34).

Skill level: Intermediate ◼◼◼◻

Size: Child (Adult Medium, Adult Large)

Circumference: 18 (20½, 22)"

MATERIALS

MC: 1 skein of Aurora 8 from Karabella (100% extrafine merino wool; 50g; 98 yds) in color 22 dark gray (4)

CC: 1 skein of Supersock DK from Cherry Tree Hill (100% superwash merino wool with high twist; 4 oz; 340 yds) in color Spring Frost (3)

2 US 7 (4.5 mm) circular needles (16")

Tapestry needle

9 stitch markers

3 bobbins (optional)

GAUGE

24 sts and 24 rnds = 4" in twined knitting

STITCH PATTERNS

Check (multiple of 4 sts)

Work with 1 strand MC and 1 strand CC. Do not twine strands between 2 same-color sts. Only twine strands between different-color sts.

Rnds 1 and 2: *K2 CC, twine strands, K2 MC, twine strands, rep from * around.

Rnds 3 and 4: *K2 MC, twine strands, K2 CC, twine strands, rep from * around.

Bird Tracks (multiple of 2 sts)

Chart on page 66.

Rnd 1: With 1 strand MC and 1 strand CC, *TK1 MC, TK1 CC, rep from * around.

Rnd 2: With 2 strands MC, TK around.

Rnd 3: With 1 strand MC and 1 strand CC, *TK1 CC, TK1 MC, rep from * around.

Rnd 4: With 2 strands MC, TK around.

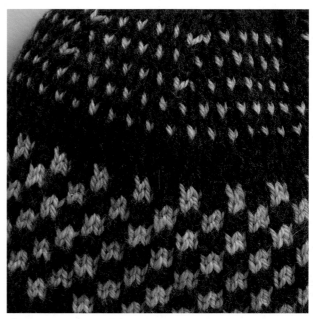

Easy-to-knit patterns make a very pretty hat.

This pattern is worked in the rnd from brim to crown. If you work from bobbins, wind 1 bobbin of CC and 2 bobbins of MC.

BRIM

With 2 strands MC and using "Twisted German Cast On" (page 14), CO 108 (124, 132) sts onto circular needle (not counting slipknot). Remove slipknot and sl first st pw from LH needle to RH needle, being careful not to twist sts and beg working in the round. Tighten loops.

Rnds 1 and 3: TK MC around in usual manner, bringing back strand *over* front strand.

Rnd 2: TK into sl st, TP MC around, twine by bringing back strand *over* front strand.

Rnd 4: TK MC around, twine by bringing back strand *under* front strand.

Rnds 5–16: Work in check patt.

Rnds 17 and 18: Work only first 2 rnds of check patt.

Rnds 19–22: TK MC around.

CROWN

The first 9 rows are worked in bird tracks patt. To maintain patt after dec rnds, look at the st 2 rows below st about to be knit and knit with other color. Cont in patt through next dec. Switch to 2 circular needles when there are too few sts to work on 1 needle.

Rnds 1–4: Work even in bird tracks patt.

Rnd 5: Work row 1 of bird tracks patt.

Rnd 6 (Child): With 2 strands MC, *TK10 sts, TK2tog, pm, rep from * around—99 sts.

Rnd 6 (Adult Medium): With 2 strands MC, TK13 sts, pm, *TK12 sts, TK2tog, pm, rep from * 3 more times; TK13 sts, pm, *TK12 sts, TK2tog, pm, rep from * 2 more times—117 sts.

Rnd 6 (Adult Large): With 2 strands MC, *TK14 sts, pm, TK13 sts, TK2tog, pm, TK13 sts, TK2tog, pm, rep from * 2 more times—126 sts.

Rnd 7 (all sizes): Work row 3 of bird tracks patt.

Rnd 8 (all sizes): With 2 strands MC, *TK until 2 sts before marker, TK2tog, sm, rep from *—90 (108, 117) sts.

Rnd 9 (all sizes): Work row 1 of bird tracks patt.

Rep rnd 8 until 9 sts rem.

Final rnd: With MC, TK1, *TK2tog, rep from * to end of rnd—5sts.

Cut strands, leaving 6" tails. With tapestry needle, pull 1 yarn tail through rem sts and cinch tight. Weave in ends.

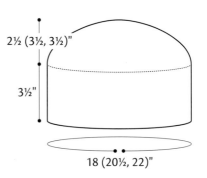

2½ (3½, 3½)"

3½"

18 (20½, 22)"

Bird Tracks
(multiple of 2 sts)

4
3
2
1

◼ MC
☐ CC

Frosty-Morning Mittens

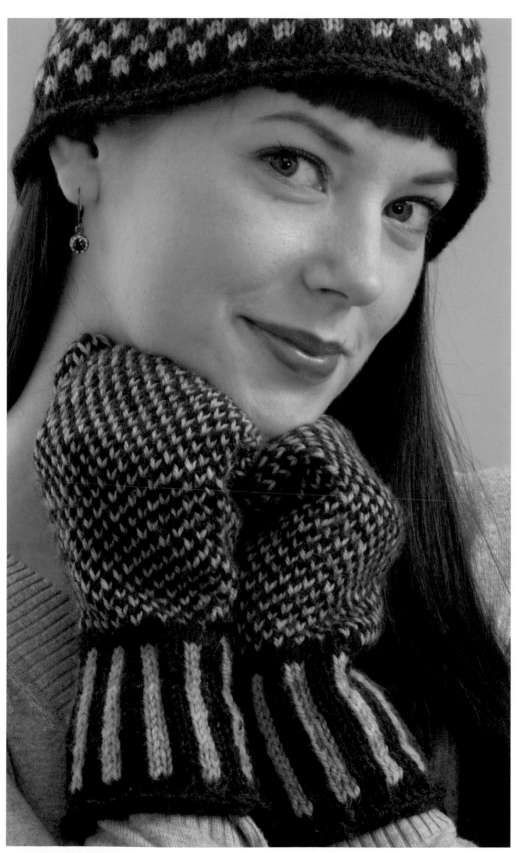

Snug mittens coordinate with the Frosty-Morning Hat (page 65) and Frosty-Morning Socks (page 70).

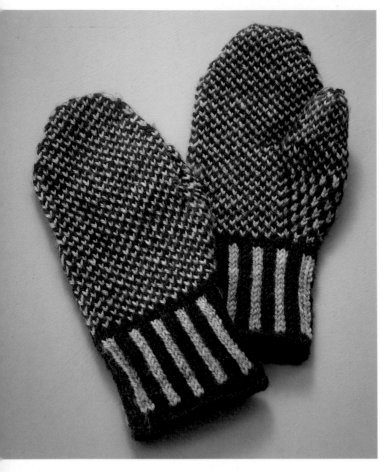

Skill level: Intermediate ■■■☐

Size: Child (Adult Medium, Adult Large)

Circumference: 6 (7¼, 8¼)"

MATERIALS

MC: 2 skeins of Aurora 8 from Karabella (100% extra fine merino wool; 50g; 98 yds) in color 22 dark gray ❨4❩

CC: 1 skein of Supersock DK from Cherry Tree Hill (100% superwash merino wool; 4 oz; 340 yds) in color Spring Frost ❨3❩

2 US 7 (4.5 mm) circular needles (16")

US 7 (4.5 mm) double-pointed needles

6" smooth waste yarn

Tapestry needle

2 stitch markers

3 large bobbins (optional)

GAUGE

24 sts and 24 rnds = 4" in twined knitting

STITCH PATTERNS

Work patts with 1 strand MC and 1 strand CC.

Stripe (even number sts)

Do not twine strands between 2 sts knit in same color. Only twine strands between 2 different colors.

*K2 MC, twine strands, K2 CC, twine strands, rep from * around.

Check (odd number sts)

To maintain check, always knit with different color than st being knit into (MC into CC st, CC into MC st) *except* in thumb gusset. There, the incs will create a 2-row elongated check patt.

Rnd 1: TK1 CC,*TK1 MC, TK1 CC, rep from * around.

Rnd 2: TK1 MC, *TK1 CC, TK1 MC, rep from * around.

LEFT MITTEN

Cuff

With 2 strands MC and using "Twisted German Cast On" (page 14), CO 36 (44, 50) sts onto circular needle (not counting slipknot). Remove slipknot and carefully arrange sts evenly on 2 circular needles. Sl first st pw from LH needle to RH needle, being careful not to twist sts and beg working in the rnd. Tighten loops.

Rnd 1: With 2 strands MC, TP around.

Rnds 2–4: At beg of rnd 2, TP into sl st, otherwise TK MC around.

Work in stripe patt for 8 (16, 18) rnds.

With 2 strands MC, TK around.

TK MC around until 1 st rem, M1—37 (45, 51) sts.

Thumb Gusset

Work incs with color that will maintain check patt on row being knit. If you alternate colors with every st, the patt will be correct. In gusset section only, the check will extend 2 rows, creating an elongated check. In palm section, the check patt will be 1 row.

Rnd 1: TK in check patt to 5 sts before end of rnd, pm, TK3 in patt, pm, TK2 in patt.

Rnd 2: TK in check patt to marker, sm, M1, TK in patt to marker, M1, sm, TK in patt to end of rnd—39 (47, 53) sts.

Rnd 3: TK even in check patt.

Rep rnds 2 and 3 until 13 (15, 17) gusset sts rem between markers—47 (57, 65) sts.

Work 0 (5, 6) rnds even in check patt.

TK to first marker. Place 13 (15, 17) sts on waste yarn.

With "Alternating Color Long-Tail Cast On" (page 75), CO 3 (5, 5) sts, alternating colors to keep in check patt. TK in small check patt to end of rnd—37 (47, 53) sts.

Palm

Arrange sts 19/18 (24/23, 27/26) on 2 circular needles, keeping thumb gusset 3 sts from end of 2nd needle.

TK even in check patt 6 (12, 20) rnds or to tip of little finger. On last 2 sts of last rnd, TK2tog—36 (46, 52) sts.

Decrease Rounds

Work decs with color that maintains check patt. The last st of rnd 2 and the first st of the dec rnd will be worked in same color.

Rnd 1: *TK2tog, work in check patt until 2 sts before end of first needle. SSTK, rep from * for 2nd needle—32 (42, 48) sts.

Rnd 2: Work even in check patt.

Rep rnds 1 and 2 until 12 (14, 12) sts rem.

Graft sts tog with "Kitchener Stitch" (page 24).

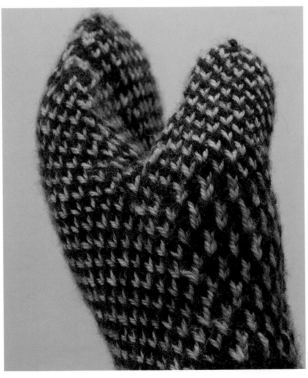

The increase area of the thumb gusset automatically forms an elongated check pattern. The remainder of the palm is a small check pattern.

Thumb

Sl sts from waste yarn onto 2 dpn. Join 1 strand MC and 1 strand CC and work sl sts in check patt. With 3rd dpn, PU 1 st at corner. At base of thumb PU 3 (5, 5) sts. PU 2 sts at 2nd corner—19 (23, 25) sts.

Arrange sts evenly on dpns and work 1 rnd in check patt, TK2tog at corners that were PU in last rnd—17 (21, 23) sts.

TK even in check patt to thumbnail, approx 1 (1½, 2)".

*TK2tog MC, TK2tog CC, rep from * around until 5 sts rem.

Cut strands, leaving 6" tails. Thread yarn through tapestry needle and pull through sts, cinch tight.

Weave in ends, mist, and block.

RIGHT MITTEN

Work right mitten same as left, reversing shaping for gusset, placing near beg of round instead of end. Beg gusset as follows:

Rnd 1: TK2 in check patt, pm, TK3 in check patt, pm, TK in check patt to end of rnd.

After completing gusset, follow left mitten palm, dec rnds, and thumb instructions.

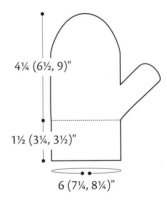

4¼ (6½, 9)"

1½ (3¼, 3½)"

6 (7¼, 8¼)"

Frosty-Morning Socks

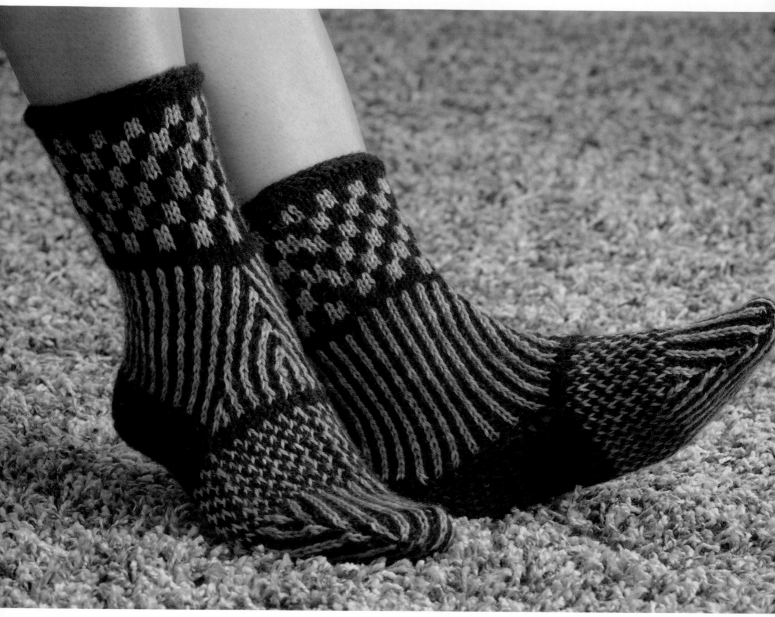

These socks have textured cuffs, slimming
ankles, and a thick, hard-wearing heel area.
Unlike stranded methods for colorwork,
twined knitting creates a nice, stretchy sock.

Skill Level: Experienced ◖■■■▶

Size: Women's Medium

MATERIALS:

MC: 2 skeins of Aurora 8 from Karabella (100% extra-fine merino wool; 50g; 98 yds) in color 22 dark gray (**4**)

CC: 1 skein of Supersock DK from Cherry Tree Hill (100% superwash wool; 4 oz; 340 yds) in color Spring Frost (**3**)

2 US 7 (4.5 mm) circular needles (16" or 24")

Tapestry needle

14 stitch markers

2 large bobbins (optional)

GAUGE

24 sts and 24 rnds = 4" in twined knitting

STITCH PATTERNS

Work with 1 strand MC and 1 strand CC.

Large Check (even number sts)

Do not twine between 2 consecutive same-color sts. Carry yarn loosely and only twine strands between sts made with different colors.

Rnds 1–3: *K2 CC, twine strands, K2 MC, twine strands, rep from * around.

Rnds 4–6: *K2 MC, twine strands, K2 CC, twine strands, rep from * around.

Zigzag Stripe (even number sts)

Rnd 1: *TK1 CC, TK1 MC, rep from * around, twining in usual manner and bringing back strand *over* front strand.

Rnd 2: *TK1 CC, bringing back strand *under* front strand, TK1 MC, bringing back strand *under* front strand, rep from * around.

Zigzag Small Check (odd number sts)

Rnd 1: TK1 CC, *TK1 MC, TK1 CC, twining in usual manner, bringing back strand *over* front strand, rep from * around.

Rnd 2: TK1 MC, *TK1 CC, TK1 MC, twining back strand *under* front strand, rep from * around.

Small Stripe (even number sts)

Always knit with same color strand as st being knit into (MC in MC, CC in CC).

*TK1 MC, TK1 CC, rep from * around.

These socks are worked in the round from cuff to toe and feature a modified short-row heel. The heavier-weight MC makes a nice, sturdy heel. To make untwisting easier, I wind a bobbin of each color.

CUFF

With 2 strands MC and using "Twisted German Cast On" (page 14), CO 48 sts (not counting slipknot) onto circular needle. Remove slipknot and carefully divide sts evenly on 2 circular needles. Sl first st pw from LH needle to RH needle to beg working in the round, being careful not to twist sts. Tighten loose loops.

Rnd 1: TP MC around.

Rnd 2: TP MC in previously slipped stitch, TK MC around.

Rnds 3–5: TK MC around.

Rnds 6–24: Work in large check patt, adjusting length as desired for longer or shorter cuff.

Rnd 25: TK MC around—24 sts on each needle.

Rnd 26: With MC on needle 1, TK11, pm, TK1, pm, TK1, pm, TK11; on needle 2, TK to end.

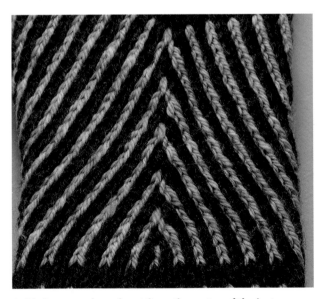

Ankle increases branch out from the center of the instep.

INSTEP INCREASES

Incs lie on top of foot (instep) and require 2 consecutive M1 incs between same 2 sts. This is not as difficult as it sounds because there are 2 bars between each st, not just 1 as in conventional knitting. Make first inc using bar that matches color to be knit. Use other bar for 2nd inc. PU bar color and knit with color strand that maintains stripe patt.

Rnd 1: TK in zigzag stripe patt to marker, sm, TK1 MC, M1 CC, sm, M1 MC, TK1 CC, sm.

TK, maintaining zigzag stripe patt to end of rnd—50 sts.

Even-number rnds: Work even in zigzag stripe patt.

Rnds 3, 5, 7, 9, 11, 13, 15, 17, 19, 21: TK in zigzag stripe patt to first marker, sm, TK in patt to 2nd marker; maintaining zigzag stripe patt, M1 with 1 strand, sm, M1 with other strand, TK in patt to 3rd marker, sm, TK in patt to end of rnd—24 sts between first and 3rd markers, 70 sts total at end of rnd 21.

Rnd 22: Work only sts on first needle in zigzag stripe patt, removing 2nd marker as you come to it.

HEEL

Heel is shaped using "Short Rows" (page 29), knitting back and forth with 2 strands MC on 2nd needle only. (24 sts on needle 2). Create zigzag stitch patt for heel and sole by twining back strand *over* front strand when knitting and back strand *over* front strand when purling.

Row 1: With 2 strands MC, TK until 2 sts before end of needle, w&t, pm.

Row 2: TP, bringing back strand *over* front strand, until 2 sts before end of needle, w&t, pm.

Row 3: TK to 1 st before marker, w&t, pm.

Row 4: TP, bringing back strand *over* front strand, to 1 st before marker; w&t, pm.

Rep rows 3 and 4 until there are 7 wraps, plus the first unwrapped st, on each end (ending with a purl-side row).

Next row: On right side of work, TK to first wrap, lift wrap loop and place over and to left of st, TK st and wrap tog tbl, cont to end of row, TK sts and wraps tog, removing markers as you come to them. At last wrapped st, pick up wrap as before, TK tog tbl of st, wrap, and last st on needle.

Next row: Turn work. Sl first st pw, TP back across row to first wrap, lift wrap from knit side of work and place over and to left of st, TP st and wrap tog, cont to end of row, TP sts and wraps tog, removing markers as you come to them. At last wrapped st, pick up wrap as before, TP tog tbl of st, wrap, and last st on needle—22 sts on (heel and sole) needle.

SOLE

From needle 1 (instep), transfer 11 sts from each side of instep to each side of needle 2 heel sts (these sts are outside markers surrounding inc st area)—11 sts + 22 sts + 11 sts = 44 sts on needle 2). Sole is worked back and forth on needle 2.

The working yarns are inaccessible. Transfer 11 sts closest to working yarn to opposite end of same needle to make working yarns accessible. (The work cont back on sts just worked, not across sl sts. Sl sts are joined with sole sts one at a time on subsequent rows.)

Row 1: On right side of work, sl first stitch pw, TK MC until 1 st before gap between heel sts and slipped instep sts. SSTK; turn work and snug yarn tight.

Row 2: Sl first stitch pw; TP MC until first stitch before gap; TP2tog; turn.

Rep rows 1 and 2 until 1 st after gap on purl side rem, turn so RS is facing you.

Sl first st pw, TK to last st before gap, SSTK, cont around in MC zigzag patt, working across instep sts on needle 1. You are back to working in the round. TK in zigzag patt to end of rnd; there will be 1 st on outside of gap, TK2tog over gap when it's reached—24 instep sts on needle 1 and 22 sole sts on needle 2 for a total of 46 sts.

FOOT

Rnd 1: TK MC around, bringing back strand *under* front strand to create zigzag st.

Rnd 2: TK MC around in normal fashion, bringing back strand *over* front strand until 1 st rem, M1—47 sts.

Rnds 3–14: TK in zigzag small check patt (or until heel to beg of toe is desired length) until 2 sts rem in rnd 14, TK2tog—46 sts.

TOE

Work in small stripe patt. Make each dec with color strand that maintains patt.

Rnd 1: *SSTK, TK in patt until 2 sts from end of first needle, TK2tog, rep from * for 2nd needle—42 sts.

Rnd 2: Work even in patt.

Rep rnds 1 and 2 until 18 sts rem. As you work, if toe looks too long for your foot, work rnd 2 only a couple of times, then work rnd 1 only.

Final rnd: Needle 1 (instep) has 10 sts and needle 2 (sole) 8 sts. Work rnd 1 dec on needle 1 only, TK in patt rem part of rnd—16 sts evenly divided on 2 needles.

Graft ends tog with "Kitchener Stitch" (page 24).

Weave in ends, mist, and block.

Green Striped Mittens

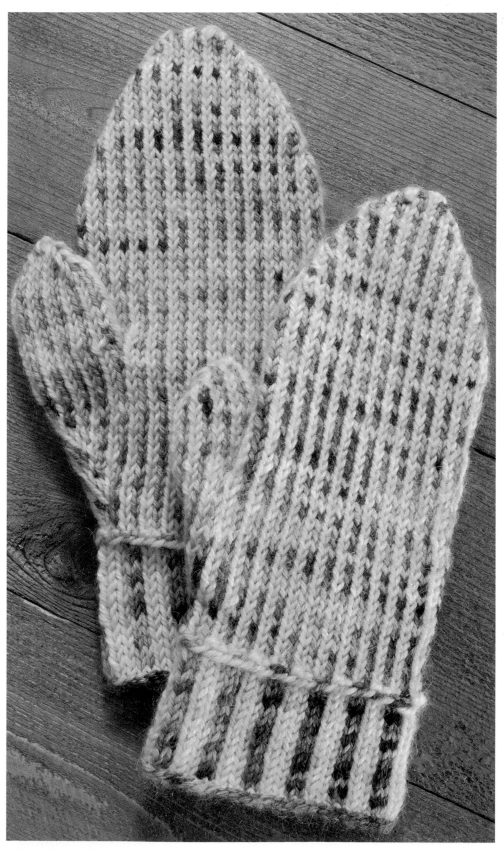

Mittens are very warm when made with twined knitting. This stripe pattern is well suited to the mitten shape, and the thumb gusset is easy to work.

Skill level: Intermediate ◼◼◼◻

Size: Child (Adult Medium, Adult Large)

Circumference: 6 (8, 8½)"

MATERIALS

MC: 2 skeins of Serengeti from Curious Creek (100% superwash merino wool; 50g; 123 yds) in color Birches in Norway **③**

CC: 3 skeins of Nakuru from Curious Creek (55% mohair/45% wool; 50g; 71 yds) in color Tilting the Gizmo **④**

2 US 6 (4 mm) circular needles (16")

US 6 (4 mm) double-pointed needles (6")

2 stitch markers

Tapestry needle

Large bobbins (optional)

GAUGE

24 sts and 24 rnds = 4" in twined knitting

STITCH PATTERNS

Work patts with 1 strand MC and 1 strand CC. Maintain stripe patt by always knitting with same color as st being knit into (MC into MC st, CC into CC st).

Large Stripe (multiple of 4 sts)

Do not twine between 2 consecutive sts made with same color. Only twine between sts of different colors.

*K2 MC, twine strands, K2 CC, twine strands, rep from * around.

Small Stripe (even number sts)

*TK1 MC, TK1 CC, rep from * around.

LEFT MITTEN

This project is worked in the round from cuff to tip.

Cuff

Use "Twisted German Cast On" method (page 14), running MC strand over thumb and CC strand over index finger, and CO 36 (48, 52) sts not counting slipknot. Remove slipknot and carefully divide sts evenly between 2 circular needles. Sl first st pw from LH needle to RH needle, being careful not to twist sts and beg working in the round. Tighten loops.

Work in large stripe patt 10 (13, 18) rnds.

Next rnd: Sl first st pw, *TP1 MC, TP1 CC, rep from * around, TP into the first sl st.

Work 1 (3, 4) rnds in small stripe patt.

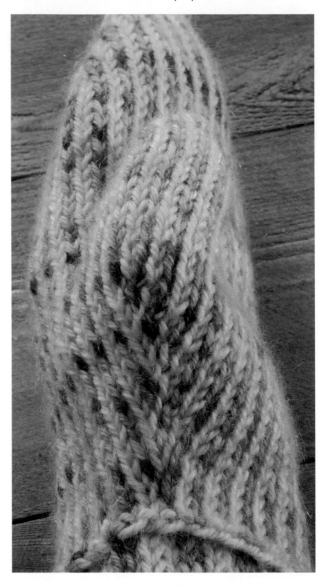

Stripe pattern continues through the thumb gusset.

Thumb Gusset

Work incs, picking up bar between sts and knitting with strand color that maintains small stripe patt. Every 2 inc rnds, the inc will create 2 sts of same color side by side. In next inc rnd, work incs with color that will even out stripe patt, otherwise *always use same color as st you are knitting into.*

Rnd 1: Work in small stripe patt until 3 sts from end of rnd, pm, M1, M1, pm, TK rem sts in patt—38 (50, 54) sts.

Rnd 2 (Adult Medium and Large sizes only): Work 1 rnd even in small stripe patt.

Inc rnd (all sizes): Work in small stripe patt to marker, sm, M1, TK in patt to marker, M1, sm, work in patt to end of rnd—40 (52, 56) sts.

Child size only: Rep inc rnd 3 more times—46 sts.

Adult Medium only: Rep rnd 2 and inc rnd 5 more times—62 sts.

Adult Large only: Rep rnd 2 and inc rnd 6 more times—68 sts.

Work 0 (2, 6) rnds even in small stripe patt.

Palm

Rnd 1: Work in small stripe patt to marker, remove marker, Place 10 (14, 16) sts on waste yarn; with right needle CO 4 sts using "Alternating Color Long-Tail Cast On" method below and alternating MC and CC to maintain stripe patt, cont in patt to end of rnd—40 (52, 56) sts.

Work in small stripe patt 6 (16, 20) rnds or until mitten length reaches end of little finger, adjusting number of rnds as necessary.

ALTERNATING COLOR LONG-TAIL CAST ON

In a normal two-color long-tail cast on (page 13), one color of yarn ends up on the needle and the other color of yarn creates the bottom edge. To maintain a striped pattern while casting on, every stitch on the needle needs to alternate color. To make an alternating color long-tail cast on, work the first cast-on stitch holding the color of yarn that will maintain the striped pattern over your index finger and the second color of yarn over your thumb. (The yarn held over your index finger is the strand that will end up on the needle.) Switch the position of the yarns over your index finger and thumb for the second cast-on stitch.

Decrease Rounds

Check to be certain there are 20 (26, 28) sts on each needle. In the following rnds, 2 dec are made tog at each side of mitten. Work dec with color that maintains stripe patt.

Rnd 1: *TK2tog, work in small stripe patt until 2 sts before end of first needle, SSTK, rep from * for 2nd needle—36 (48, 52) sts.

Rnd 2: Work even in patt.

Rep rnds 1 and 2 until 6 (8, 10) sts rem on each needle.

Graft sts tog with "Kitchener Stitch" (page 24) and weave in ends.

Thumb

Rnd 1: Sl sts from waste yarn evenly to 2 dpns. Remove waste yarn.

With 1 strand MC and 1 strand CC, TK sts on dpns, working in small stripe patt. With 3rd dpn, PU 1 st at corner to close gap, PU and knit in patt 4 sts at base of thumb, and PU 1 st at other corner—16 (20, 22) sts.

Rnd 2: Work in small stripe patt, dec 1 st at each corner—14 (18, 20) sts.

Work even in small stripe patt 6 (8, 9) rnds or until length reaches thumbnail, adjusting number of rnds as needed.

Arrange sts evenly on 2 dpns.

Dec rnd: *TK2tog, work in small stripe patt to 2 sts before end of first needle, SSTK, rep from * around—10 (14, 16) sts.

Rep dec rnd until 6 (6, 4) sts rem.

Cut strands, leaving 6" tail. Thread yarn through tapestry needle and pull through sts. Cinch tight and weave in ends.

RIGHT MITTEN

Work right mitten same as left, reversing shaping for gusset, placing near beg of rnd instead of end. Beg gusset as follows:

Rnd 1: TK3 sts in small stripe patt, pm, M1, M1, pm, TK in stripe patt to end.

After completing gusset, follow left mitten palm, dec rnds, and thumb instructions.

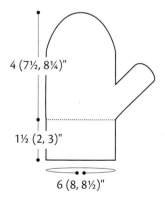

4 (7½, 8¼)"

1½ (2, 3)"

6 (8, 8½)"

Traditional Mittens

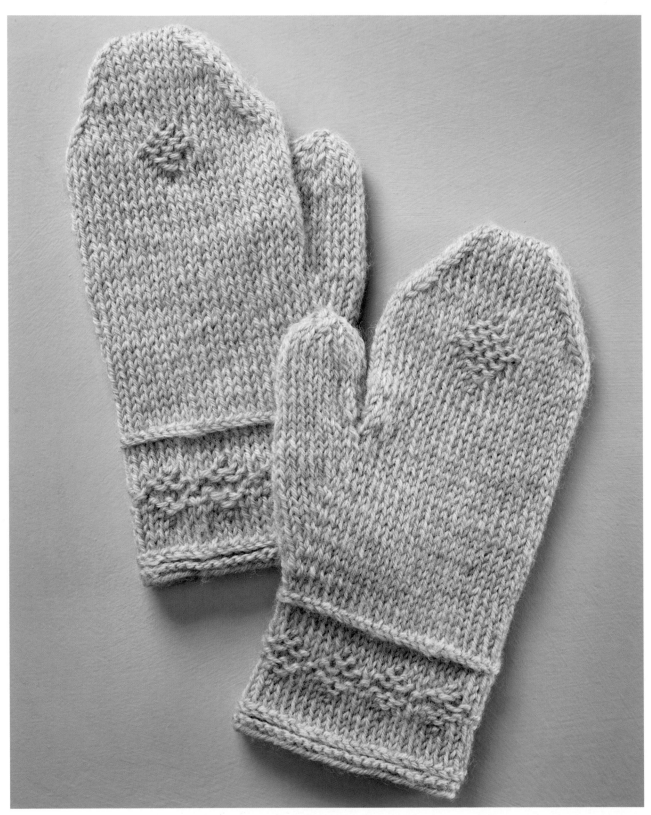

Texture makes the pattern on this pair of traditional mittens.
They go wonderfully with the Traditional Textured Hat on page 51.

Skill Level: Intermediate ◼◼◼◻

Sizes: Child (Adult Medium, Adult Large)

Circumference: 6½ (8¼, 9)"

MATERIALS

2 balls of Falk from Dale of Norway/Dalegarn (100% machine-washable wool; 50g; 116 yds) in color 2931 Light Sheep Heather (**2**)

2 US 5 (3.75 mm) circular needles (16" or 24")

US 4 (3.5 mm) double-pointed needles (5" or 6")

Stitch holder or 6" smooth waste yarn

2 stitch markers

Tapestry needle

2 large bobbins (optional)

GAUGE

26 sts and 26 rnds = 4" in twined knitting

RIGHT MITTEN

This pattern is worked in the rnd on 2 circular needles from cuff to tip. If you like to use bobbins, wind 2 very full, otherwise pull 1 strand from each yarn ball.

Follow charts on page 78 for cuff and diamond patts. Patts are variations of crook stitch (See "Crook Stitch" on page 14). When making a knit st between 2 purl sts, keep purl strand to front of work and make knit st with back strand. Strands are not twined. Return purl strand to back of work after last purl st.

Cuff

With 2 strands and using "Twisted German Cast On" method (page 14), CO 36 (48, 60) sts (not counting slipknot) onto 1 circular needle. Remove slipknot and carefully divide sts evenly between 2 needles. Sl first st pw from LH needle to RH needle and beg working in the rnd, being careful not to twist sts. Tighten loops.

Rnd 1: TK around.

Rnds 2 and 3: TK around.

Rnd 4: Sl first st pw, TP around; TP into sl st at beg of next rnd.

TK around 2 (4, 7) rnds.

Next 7 rnds: Work cuff patt chart on page 78.

TK around 1 (4, 7) rnds.

Sl first st pw, TP around.

TP into slipped st, TK around.

Child's size only: TK1, M1, TK until 1 st rem, M1, TK1—38 sts.

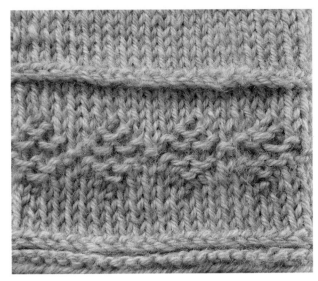

The cuff pattern is a variation of the crook stitch.

Thumb Gusset

Rnd 1: TK5, pm, TK3, pm, TK to end of rnd.

Rnd 2: TK to marker, sm, M1, TK to marker, M1, sm, TK to end of rnd—40 (50, 62) sts.

Rnd 3 (Adult Medium and Adult Large sizes): TK around.

Child size only: Rep rnd 2 until 11 sts between markers—46 sts total.

Adult Medium and Adult Large sizes only: Rep rnds 2 and 3 until (17, 19) sts between markers—(62, 76) sts total.

TK even for 0 (3, 7) rnds.

Next rnd: TK to marker, place 11 (17, 19) gusset sts between markers on smooth waste yarn, removing markers. Using 2 strands and "Two-Strand Long-Tail Cast On" method, CO 3 (5, 5) sts onto RH needle to cover gusset gap, TK to end of rnd—38 (50, 62) sts.

Palm

TK even 6 (10, 20) rnds. There should be 19 (25, 31) sts on each needle.

Beg diamond patt and shaping:

Rnd 1: TK25 (34, 43), work row 1 of diamond patt, TK to end of rnd.

Rnd 2: TK25 (34, 43), work row 2 of diamond patt, TK to end of rnd.

Rnd 3: TK25 (34, 43), work row 3 of diamond patt, TK to end of rnd.

Rnd 4: TK1, SSTK, TK13 (19, 25), TK2tog, TK2, SSTK, TK3 (6, 9), work row 4 of diamond patt, TK3 (6, 9), TK2tog, TK1—34 (46, 58) sts.

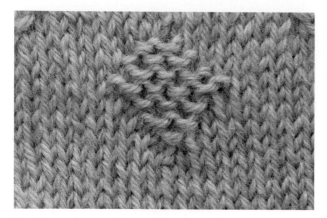

The diamond pattern is a traditional motif.

Rnd 5: TK22 (31, 40), work row 5 of diamond patt, TK to end of rnd.

Rnd 6: TK1, SSTK, TK11 (17, 23), TK2tog, TK2, SSTK, TK2 (5, 8), work row 6 of diamond patt, TK2 (5, 8), TK2tog, TK1—30 (42, 54) sts.

Rnd 7: TK19 (28, 37), work row 7 of diamond patt, TK to end of rnd.

Rnd 8: *TK1, SSTK, TK to 3 sts before end of needle, TK2tog, TK1, rep from * around—26 (38, 50) sts.

Rnd 9: TK around.

Rep rnds 8 and 9 until 10 (18, 22) sts rem.

Final rnd: TK even around, distributing sts evenly on 2 needles; palm sts on one needle, back of hand sts on other needle.

Graft sts tog with "Kitchener Stitch" (page 24). Cut strands and weave in ends.

Thumb

Rnd 1: Sl sts from waste yarn evenly to 2 dpns; with 3rd dpn, alternate 2 strands of yarn and PU 1 st before CO sts, the CO sts, and 1 st after the CO sts—16 (24, 26) sts.

Rnd 2: TK17, TK2tog, TK5, TK2tog—14 (22, 24) sts.

TK even 1 (1½, 2½") or until length reaches middle of thumbnail, adjusting number of rnds as needed.

Final rnds: *TK2tog, rep from * around until 4 (5, 3) sts rem.

Finishing: Cut 5" yarn tails. Thread tails on tapestry needle, sl sts from knitting needles to tapestry needle, and cinch tight.

Weave in ends.

LEFT MITTEN

Work cuff as for right mitten.

Left thumb gusset is worked as for right, but shaping is reversed.

Rnd 1 of gusset: TK until 8 sts rem, pm, TK3, pm, TK5.

Work thumb gusset as for right mitten, reversing shaping and making inc between markers at end of round.

Top of left mitten is worked as for right, reversing shaping. Beg of palm diamond patt and shaping is given below.

Rnd 1: TK 6 (9, 12), work row 1 of diamond patt, TK to end.

Work thumb as for right mitten.

Cuff Pattern
(6-st rep)

Diamond Pattern
(7-st rep)

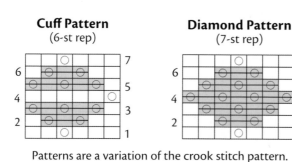

Patterns are a variation of the crook stitch pattern.

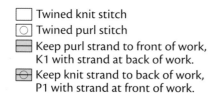

☐ Twined knit stitch
Ⓞ Twined purl stitch
▤ Keep purl strand to front of work, K1 with strand at back of work.
⊖ Keep knit strand to back of work, P1 with strand at front of work.

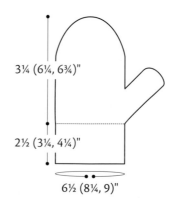

3¼ (6¼, 6¾)"

2½ (3¼, 4¼)"

6½ (8¼, 9)"

Natural Heather-Striped Mittens

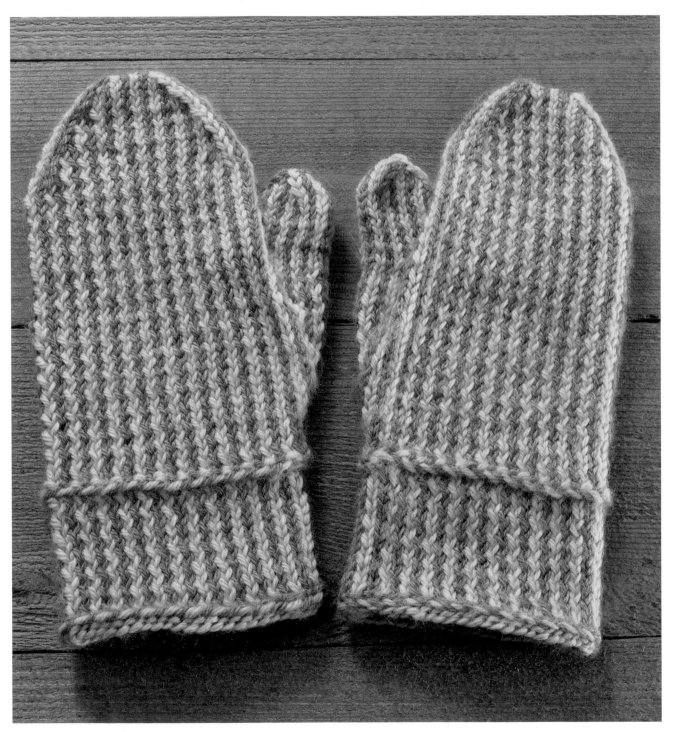

Twisting tradition, these mittens are made of two similar yarns twined in opposite directions every row, creating the zigzag pattern. By alternating the yarn twist direction, the yarns don't kink and the unique squiggles appear.

Skill level: Intermediate ◼◼◼▢

Size: Child (Adult Medium, Adult Large)

Circumference: 6½ (8, 8¼)"

MATERIALS

MC: 2 balls of Falk from Dale of Norway/Dalegarn (100% machine-washable wool; 50g; 116 yards, 106 m) in color 3841 Medium Sheep Heather (**2**)

CC: 2 balls of 1824 Wool from Mission Falls (100% merino superwash; 50 g; 85 yds) in color 02 Stone (**4**)

2 US 7 (4.5mm) circular needles (16" or 24")

US 7 (4.5 mm) double-pointed needles (5 or 6")

12" and 6" lengths of smooth waste yarn

Tapestry needle

2 stitch markers

Size G (4.0mm) crochet hook

2 large bobbins (optional)

GAUGE

24 sts and 24 rnds = 4" in zigzag twined knitting

STITCH PATTERN

Zigzag Stripe (even number sts)

Maintain stripe by always knitting with same color as st being knit into.

Rnd 1: *TK1 MC, TK1 CC, rep from * around, twining in the usual manner, bringing back strand *over* front strand.

Rnd 2: *TK1 MC, twine by bringing back strand *under* front strand, TK1 CC, twine by bringing back strand *under* front strand, rep from * around.

RIGHT MITTEN

This pattern is worked in the round from cuff to tip on two circular needles. As you work the mittens, inc and dec will interrupt the stripe patt and occasionally place 2 same-color sts tog. Keep in stripe patt by always knitting with the same color as the stitch you are knitting into (MC in MC st, CC in CC st). The next inc or dec will restore the stripe patt.

Cuff

Using "Twisted German Cast On" method (page 14) and running CC strand over thumb and MC strand over index finger, CO 40 (48, 50) sts (not counting slipknot)

onto circular needle. Remove slipknot and carefully divide sts evenly between 2 circular needles. Sl first st pw from LH needle to RH needle and beg working in the round, being careful not to twist sts. Tighten loops.

Rnd 1: *TP1 CC, TP1 MC, rep from * around.

Rnd 2: TP into sl st using color that maintains stripe, cont around in zigzag stripe patt.

Work 12 (14, 18) rnds in zigzag stripe patt.

Next rnd: Bring both strands to front, sl first st pw, *TP1 CC, TP1 MC, rep from * around.

TP MC into sl st, then cont in zigzag stripe patt around, always using same color as st you knit into.

Work 1 (3, 4) rnds even in zigzag stripe patt.

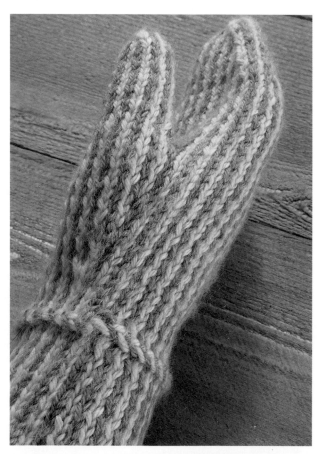

The stripe pattern is continued through and after the gusset increases.

Thumb Gusset

For RH mitten, the gusset is placed at beg of rnd. Every 2 inc rnds, the inc will create 2 sts of the same color side by side. In the next inc rnd, work the incs with the color that will even out the stripe patt, otherwise *always use same color as st you are knitting into.*

Rnd 1: TK4 in zigazag stripe patt, pm, M1 MC, TK2 (4, 4) in patt, M1 MC, pm, TK in patt to end of rnd—42 (50, 52) sts.

Rnd 2 (Adult Medium and Large sizes only): Work even in zigzag stripe patt.

Inc rnd all sizes: Work in patt to marker, sm, M1 using color that evens up stripe patt, work in patt to 1 st before marker, M1 using color that evens up stripe patt, sm, TK in patt to end of rnd—44 (52, 54 sts).

Child size: Rep inc rnd until 12 sts between markers—(50 sts)

Adult Medium and Large sizes: Rep rnd 2 and inc rnd until (16, 18) gusset sts—(60, 64) sts total.

All sizes: TK in patt evenly 0 (6, 6) rnds or until gusset reaches crotch of thumb. Adjust number of rnds as needed.

TK4 in patt, remove marker, place 12 (16, 18) gusset sts on 6" strand of waste yarn. Remove marker. Using "Long Tail Cast On," CO 2 (4, 4) sts to cover gusset gap, alternating colors to match stripe patt (see tip on page 75).

Palm

Maintaining stripe patt, TK around—40 (48, 50) sts.

Rem rnds: TK around in patt 12 (15, 20) rnds or until length of mitten reaches top of little finger, adjusting number of rnds as needed.

Decrease Rounds

Check to be certain 20 (24, 25) sts are on each circular needle. Every 4 rnds, the dec will create 2 sts of the same color side by side. In the next dec rnd, these sts will be dec tog, reestablishing stripe patt.

Rnd 1: *TK1 MC, SSTK CC, TK in patt to 3 sts from end of needle, TK2tog MC, TK1*, rep from * for sts on 2nd needle—4 sts dec per rnd.

Rnd 2: Work even in zigzag stripe patt, *always using the same color as the st you are knitting into.*

Rep rnds 1 and 2 until 4 (12, 18) sts rem.

Cut yarns, leaving a 3" tail and a 6" tail. Thread 6" tail on tapestry needle and graft top edges tog with "Kitchener Stitch" (page 24). Weave in ends.

Thumb

Sl sts from waste yarn evenly to 2 dpns, remove waste yarn. With 1 strand MC and 1 strand CC, TK sts on dpns in patt. With 3rd dpn, PU 1 st at corner to close gap, PU in patt 2 (4, 4) sts at base of thumb, and PU 1 st at other corner to complete rnd—16 (22, 24) sts.

TK in patt 6 (14, 16) rnds or until length of thumb, adjusting number of rnds as needed.

Arrange sts evenly on 2 dpns.

Dec rnd: Working in patt, *TK1, TK2tog, TK to 3 sts from end of needle, SSTK, TK1, rep from *—4 sts dec each rnd.

Rep dec rnd until 4 (6, 4) sts rem.

Cut strands, leaving 6" tail.

Thread yarn tails through tapestry needle and pull through sts.

Cinch tight and weave in ends.

LEFT MITTEN

Work left mitten same as right, reversing shaping for gusset, placing near end of round instead of beg. Beg gusset as follows:

Rnd 1: TK in patt until 6 (8, 8) sts rem, pm, M1, TK2 (4, 4) in patt, M1, pm, TK4.

After completing gusset, follow left mitten palm, dec rnds, and thumb instructions.

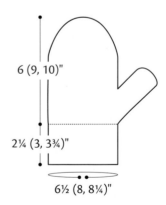

6 (9, 10)"

2¼ (3, 3¾)"

6½ (8, 8¼)"

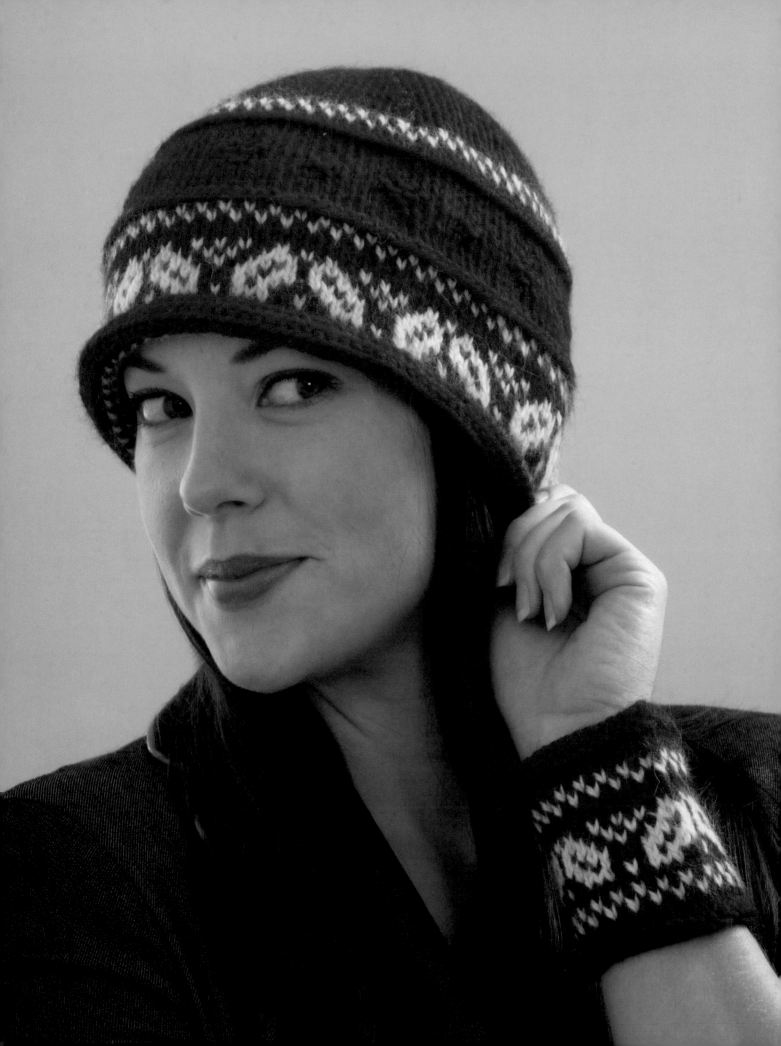

Holly-Leaves-and-Berries Hat

The patterns and textures in this hat are pretty variations on a traditional look. The majority of the hat is knit with standard twined knitting. The holly-leaves-and-berries section combines twined knitting with stranded techniques. You'll have plenty of yarn to make a set of wrist warmers to practice the stitches and techniques before you make the hat.

Skill level: Experienced ◖◼◼◼▮◗

Size: Adult

Circumference: 21"

MATERIALS

MC: 1 skein of Lana D' Oro from Cascade Yarns (50% superfine alpaca, 50% wool; 100g; 219 yds) in color 1036 red (**4**)

CC: 1 skein of Cloud 9 from Cascade Yarns (50% merino wool, 50% angora; 50g; 109 yds) in color 101 off-white (**4**)

2 US 7 (4.5 mm) circular needles (16")

Tapestry needle

9 stitch markers

3 large bobbins (optional)

GAUGE

24 sts and 24 rnds = 4" in twined knitting

STITCH PATTERNS

Small Check (odd number sts)

Rnd 1: TK1 MC, *TK1 CC, TK1 MC, rep from * around.

Rnd 2: TK1 CC, *TK1 MC, TK1 CC, rep from * around.

Holly Leaves and Berries (multiple of 14 sts)

Follow written instructions below or chart at end of project. Carry 2 MC yarns for twining in RH and 1 CC yarn for stranding in LH. See "Three-Strand Knitting" (page 28).

Rnd 1: *K3 CC, TK2 MC, K1 CC, TK2 MC, K3 CC, TK1 MC, K1 CC, TK1 MC, rep from * around.

Rnd 2: *K1 CC, TK1 MC, K2 CC, TK3 MC, K2 CC, TK1 MC, K1 CC, TK3 MC, rep from * around.

Rnd 3: *K2 CC, TK1 MC, K2 CC, TK1 MC, K2 CC, TK1 MC, K2 CC, TK3 MC, rep from * around.

Rnd 4: *TK1 MC, K2 CC, TK1 MC, K1 CC, TK1 MC, K1 CC, TK1 MC, K2 CC, TK2 MC, K1 CC, TK1 MC, rep from * around.

Rnd 5: *TK2 MC, K3 CC, TK1 MC, K3 CC, TK2 MC, K1 CC, TK1 MC, K1 CC, rep from * around

Rnd 6: *K1 CC, TK2 MC, K1 CC, TK1 MC, K1 CC, TK1 MC, K1 CC, TK2 MC, K1 CC, TK1 MC, K1 CC, TK1 MC rep from * around.

Crook Stitch (multiple of 14 sts)
See "Crook Stitch" on page 25.

Follow written instructions below or chart at end of project. Use 2 strands MC for this knit-and-purl st patt. When making a knit st between 2 purl sts, hold purl strand to front of work and make knit st with back strand. Return purl strand to back after 2nd purl st and cont, twining as usual.

Rnd 1: *TK11, TP1, TK2, rep from * around.

Rnd 2: *TK4, TP1, TK5, bring next strand to front, P1, K1, P1, bring purl strand to back, TK1, rep from * around.

Rnd 3: *TK3, bring next strand to front, P1, K1, P1, bring purl strand to back, TK3, bring next strand to front, P1, K1, P1, K1, P1, bring purl strand to back, rep from * around.

Rnd 4: Rep rnd 2.

Rnd 5: Rep rnd 1.

The crook-stitch pattern adds interesting texture to the hat.

This hat is worked in the round from brim to crown. If you are using bobbins, wind 2 of MC and 1 of CC.

BRIM

Using 2 strands of MC and "Twisted German Cast On" method (page 14), CO 127 sts (not counting slipknot) onto 1 circular needle. Remove slipknot. Sl first st pw from LH needle to RH needle and beg working in the round, being careful not to twist sts.

Rnd 1: With 2 strands of MC, TP around.

Rnds 2–5: At beg of rnd 2, TP into sl st. With 2 strands MC, TK around.

Rnds 6 and 7: Work in small check patt.

Rnd 8: With 2 strands MC, TK around until 2 sts rem, TK2tog—126 sts.

Rnds 9–14: Work in holly leaves and berries patt.

Rnd 15: With 2 strands MC, TK around.

Rnd 16: With 2 strands MC, TK around until 1 st rem, M1, TK1—127 sts.

Rnd 17 and 18: Work in small check patt.

Rnd 19: With 2 strands MC, TK around until 2 sts rem, TK2tog—126 sts.

Rnd 20: With 2 strands MC, TP around.

Rnds 21–24: With 2 strands MC, TK around.

Rnd 25–29: Work in crook st patt.

Rnds 30–33: With 2 strands MC, TK around.

Rnd 34: With 2 strands MC, TP around.

Rnd 35: With 2 strands MC, TK around.

Rnd 36: With 2 strands MC, TK around until 1 st rem, M1, TK1—127 sts.

Rnds 37 and 38: Work in small check patt until 2 sts rem at end of rnd 38, TK2tog—126 sts.

PRACTICE PROJECT

Wrist Warmers

For your gauge swatch or a small practice piece, make a pair of these cute wrist warmers.

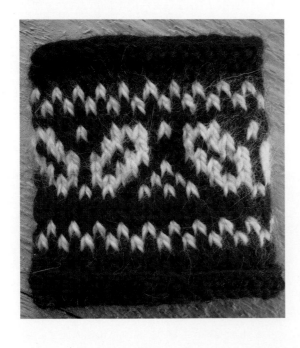

Circumference: 7"

Using 2 strands MC and "Twisted German Cast On" (page 14), CO 43 sts (not counting slipknot). Remove slipknot and carefully place 21 sts on 2nd circular needle. Sl first st pw from LH needle to RH needle to beg working in the round, being careful not to twist sts.

Rnd 1: TP MC around.

Rnds 2 and 3: TK MC around.

Rnds 4 and 5: Work in small check patt.

Rnd 6: With 2 strands MC, TK around until 2 sts rem, TK2tog—42 sts.

Rnds 7–12: Work in holly leaves and berries patt.

Rnd 13: With 2 strands MC, TK around.

Rnd 14: With 2 strands MC, TK around until 1 st rem, M1, TK1—43 sts.

Rnds 15 and 16: Work in small check patt.

Rnd 17 and 18: With 2 strands MC, TK around.

Rnd 19: With 2 strands MC, TP around.

BO all sts using sewn BO (page 23).

Using tapestry needle, weave in ends.

CROWN

Divide sts evenly between 2 circular needles. Work with 2 strands MC.

Rnd 1: *TK14, pm, rep from * around—rnd is divided in 9 equal sections.

Rnd 2: *TK until 2 sts before marker, TK2tog, sm, rep from * around—117 sts.

Rnd 3: TK MC around.

Rep rnds 2 and 3 four more times—81 sts.

Rep rnd 2 until 9 sts rem.

FINISHING

Cut strands, leaving a 6" tail. With tapestry needle, thread yarn tail through rem sts, cinch tight, pull ends to inside, and weave in. Mist and block.

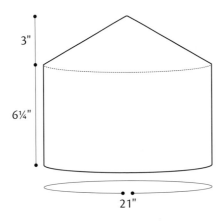

Holly Leaves and Berries Pattern
(14-st rep)

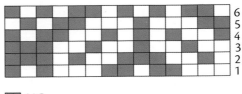

■ MC
☐ CC

Crook Stitch Pattern
(14-st rep)

☐ Twined knit stitch
◎ Twined purl stitch
▨ Keep purl strand to front of work, K1 with strand at back of work.
⊖ Keep knit strand to back of work, P1 with strand at front of work.

Tiger-Striped Socks

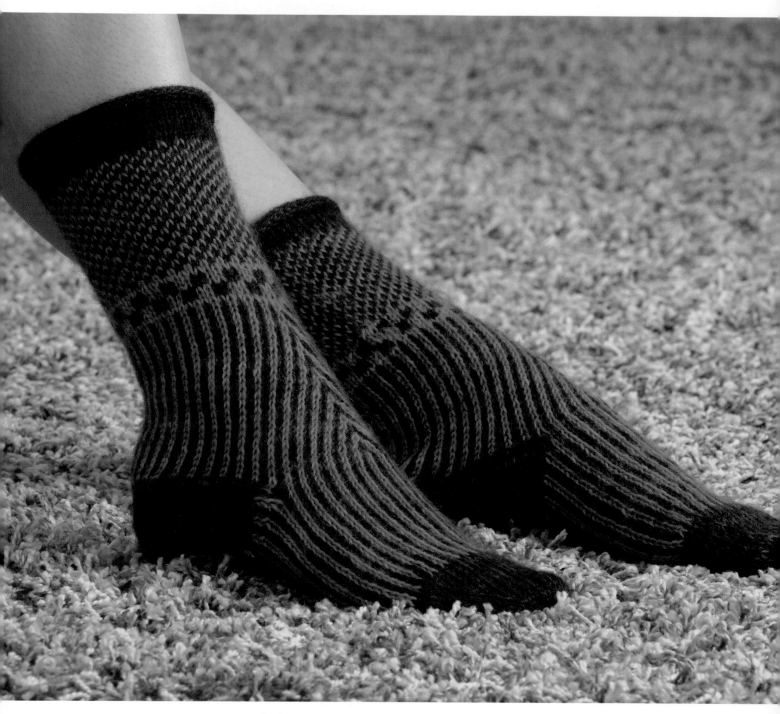

Striking patterns adorn these thick and warm socks, perfect for toasting your toes by the fire on cold winter nights.

Skill level: Experienced ◀■■▶

Size: Women's Medium (7½" cuff)

MATERIALS

Bearfoot from Mountain Colors (60% superwash wool, 25% mohair, 15% nylon; 100 g; 350 yds) (2)

MC: 1 skein in color Red Tail Hawk

CC: 1 skein in color Marigold

2 US 4 (3.5 mm) circular needles (16" or 24")

15 stitch markers

Tapestry needle

4 bobbins (optional)

GAUGE

30 sts and 32 rnds = 4" in twined knitting

STITCH PATTERNS

Work stitch patterns with 1 strand MC and 1 strand CC.

Small Check (odd number sts)

Rnd 1: TK1 CC, *TK1 MC, TK1 CC, rep from * around.

Rnd 2: TK1 MC, *TK1 CC, TK1 MC, rep from * around.

Large Check (multiple of 4 sts)

Do not twine between two consecutive same-color sts. Carry the yarn loosely and only twine strands between sts made with different colors.

Rnds 1 and 2: *K2 CC, twine strands, K2 MC, twine strands, rep from * around.

Rnds 3 and 4: *K2 MC, twine strands, K2 CC, twine strands, rep from * around.

Stripe (even number sts)

All rnds: *TK1 CC, TK1 MC, rep from * around.

These socks are worked in the rnd from cuff to toe and feature a modified short-row heel. To make untwisting easier, I wind 2 bobbins of each color.

CUFF

Using 2 strands MC and "Twisted German Cast On" (page 14), CO 57 sts (not counting slipknot) onto 1 circular needle. Remove slipknot and carefully place 29 sts on 2nd circular needle. Sl first st pw from LH needle to RH needle, to beg working in the round, being careful not to twist sts.

Rnds 1–12: With 2 strands MC, TK around.

Rnds 13–32: Work in small check patt.

Rnd 33: With 2 strands CC, TK around.

Rnd 34: With CC, TK2tog; with 2 strands CC, TK to end of rnd—56 sts.

Rnds 35–38: Work in large check patt.

Rnd 39: With 2 strands CC, TK13, pm, TK1, pm, TK1, pm, TK to end of rnd.

INSTEP INCREASES

Check that each needle has 28 sts. Incs lie on top of foot (instep) and require 2 M1 incs between same 2 sts. This is not as difficult as it sounds because there are 2 bars between each st, not just 1 as in conventional knitting. For first inc, PU bar color and knit with same color strand that maintains stripe patt. Use other bar and strand for 2nd inc.

Rnd 1: Work in stripe patt to marker, sm, TK1, M1, sm, M1, TK1, sm, TK in patt to end of rnd—58 sts.

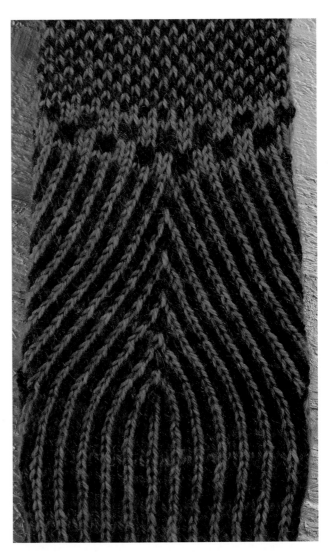

Ankle increases branch out from the center of the instep.

Even-number rnds: Work even in stripe patt.

Rnds 3, 5, 7, 9, 11, 13, 15, 17, 19, 21, 23: TK in stripe patt to first marker, sm, TK in patt to 2nd marker; M1, sm, M1, TK in patt to 3rd marker, sm, TK in patt to end of rnd —52 sts on needle 1 (instep) + 28 sts on needle 2 (heel) = 80 sts total at end of rnd 23.

Rnd 24: Work only sts on first needle in patt; sl first and third markers, remove second marker. Heel begins on needle 2.

HEEL

Heel is shaped using short rows (page 29), knitting back and forth with 2 strands MC on needle 2. To create zigzag patt used for heel and sole, twine by bringing back strand *over* front strand when knitting and bringing back strand *over* front strand when purling. Check to be certain 2nd circular needle has 28 sts.

Row 1: With 2 strands MC, TK until 2 sts before end of needle, w&t, pm.

Row 2: TP until 2 sts before end of needle, w&t, pm.

Row 3: TK to 1 st before marker; w&t, pm.

Row 4: TP to 1 st before marker; w&t, pm.

Rep rows 3 and 4 until 7 wraps plus 1 unwrapped st on each end (ending with a purl-side row).

Next row: On right side of work, TK to first wrap, lift wrap and place it to left of st on needle, TK st and wrap tog tbl, cont to end of row, TK sts and wraps tog, removing markers as you come to them. At last wrapped st, pick up wrap as before, TK tog tbl of st, wrap, and last st on needle. Turn work.

Next row: Sl first st pw, TP back across row to first wrap, lift wrap from the knit side and place it to left of st on needle, TP st and wrap tog, cont to end of row, TP wraps and sts tog, removing markers as you come to them. At last wrapped st, PU wrap as before, TP tog st, wrap, and last st on needle—26 sts on needle 2 (heel and sole).

SOLE AND FOOT

Work sole in same zigzag patt as heel, TK bringing back strand *over* front strand, TP bringing back strand *over* front strand.

Sl 13 sts from each end of instep needle 1 to each end of needle 2 heel sts (these sts are outside markers surrounding inc st area)—13 sts + 26 sts + 13 sts = 52 total sts on heel and sole needle 2. Sole is worked back and forth on needle 2.

The working yarns will be inaccessible. Transfer 13 sts closest to working yarn to opposite end of the same needle to make working yarns accessible.

Work back on sts just worked, not across sl sts. Sl sts are joined with sole sts one at a time on subsequent rows.

Rnd 1: On right side of work, sl first st pw, TK MC in zigzag patt until 1 st before gap between heel sts and sl instep sts, SSTK; turn work and snug yarn tight.

Rnd 2: Sl first st pw; TP MC until first st before gap; TP2tog, turn.

Rep rnds 1 and 2 until last st after gap on purl side is worked, turn so RS is facing you.

Sl first st pw, TK MC to last st before gap, SSTK. With 1 strand MC and 1 strand CC, cont around in stripe patt, working across instep sts. You are back to working in the round. TK last st of instep and remaining st after gap tog—54 sts.

Work 27 rnds even in stripe patt or until desired length between heel and beg of toe.

TOE

Rnd 1: *With 2 strands MC, TK1, SSTK, TK until 3 sts rem on needle 1, TK2tog, TK1, rep from * for needle 2.

Rnd 2: TK MC around.

Rep rnds 1 and 2 another 7 times until 22 sts rem—12 sts on needle 1 (instep) and 10 sts on needle 2 (sole).

Final rnd: TK1, SSTK, TK untils 3 sts rem on needle, TK2tog, TK1—10 sts on each needle, 20 sts total.

Use "Kitchener Stitch" (page 24) to graft sts tog. Weave in ends, mist, and block.

Flower-Border Bag

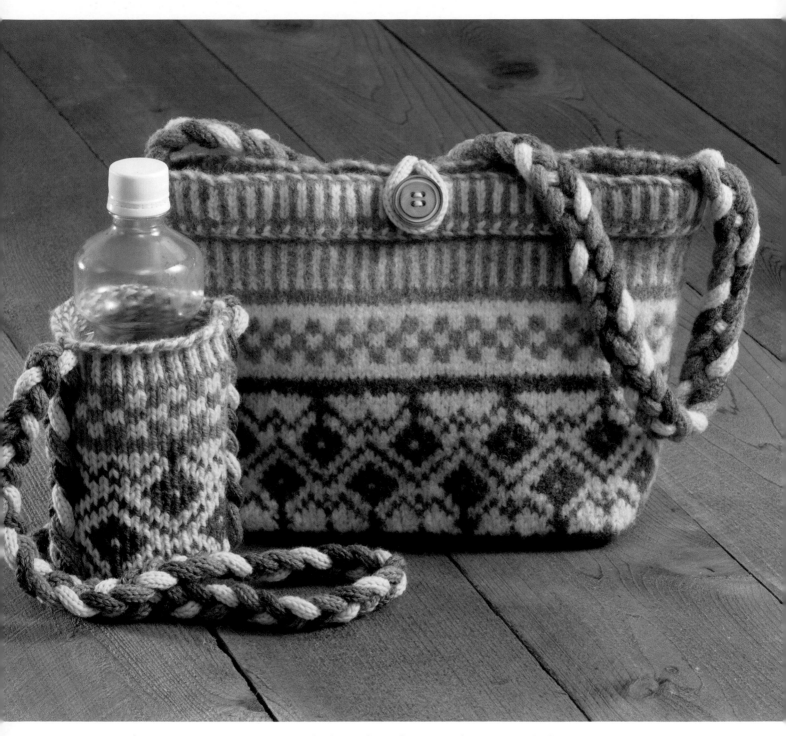

Here's a fun project I can't resist including, though most of it is stranded, not twined. This bag is knit firmly, stranding with two colors for the majority of the rounds but twining a few rows to create a textured braid. The facing folds over to the front at the top, making a firm stable edge. It is lightly felted and lined. A small version of this bag can serve as a water-bottle sleeve.

Skill level: Experienced ◆■■▶

Size: 24" circumference x 8"

MATERIALS

Cascade 220 From Cascade Yarns (100% Peruvian merino wool; 100 g; 220 yds) (④)

MC: 1 skein in color 4147B yellow

A: 1 skein in color 4010 gold

B: 1 skein in color 2417 taupe

C: 1 skein in color 2429 green

4 stitch markers

2 US 8 (5mm) circular needles (16" or 24")

Tapestry needle

Sewing needle and thread to match

½ yard of 45"-wide fabric for lining (firm, finely woven ticking or denim works well)

1" button

Sewing machine (optional)

GAUGE

20 sts and 20 rnds = 4" in stranded knitting before felting

STITCH PATTERNS

Stripe (even number sts)

Work with 1 strand MC and 1 strand A. Always knit with same color as st you are knitting into.

*K1 MC, K1 A, rep from * around.

Large Check (multiple of 4 sts)

Work with 1 strand MC and 1 strand B.

Rnds 1 and 2: K2 MC, K2 B.

Rnds 3 and 4: K2 B, K2 MC.

This pattern is worked in the round from top down. Strand solid-colored rows with 2 strands of same color. After rnds 1–18 are knit, turning the work and reversing the direction of knitting keeps right side of facing to the outside of the bag.

BODY

Use "Two-Strand Long-Tail Cast On" (page 13), circular needle, and 2 strands of A to CO 144 sts (not counting slipknot). Remove slipknot and sl first st pw from LH needle to RH needle and beg working in the round, being careful not to twist sts. Cinch loops tight.

STRANDED KNITTING

This bag is knit with a stranded Fair Isle technique instead of twining. When stranding, I usually advise holding the contrasting color in your left hand and the main color in your right. This will cause the contrast color to dominate on the main color background. I made this bag with yellow dominant in the first stripe pattern and with gold dominant in the second stripe pattern. Review "Stranded Knitting and Yarn Dominance" on page 27.

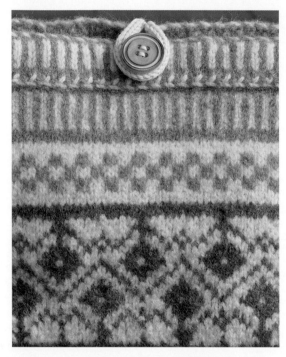

The bag is knit with two strands at all times, then lightly felted, creating a nice, thick fabric.

Rnd 1: With 1 strand MC and 1 strand A, *K1 A, K1 MC, rep from * around.

Rnd 2: TP1 MC, *TP1 A, TP1 MC, rep from * around.

Rnd 3: With 2 strands A, knit around.

Rnds 4–9: With 1 strand MC and 1 strand A, *K1 A, K1 MC, rep from * around.

Rnd 10: *TP1 MC, TP1 A, rep from * around.

Rnd 11: Sl first st pw, with 2 strands MC, knit around.

Rnds 12–18: With 2 strands MC, knit around, at end of rnd 18, *turn the work inside out and reverse direction of knitting.*

Rnds 19 and 20: With 2 strands A, knit around.

Rnds 21–26: With 1 strand MC and 1 strand A, *K1 A, K1 MC, rep from * around.

Rnds 27 and 28: With 2 strands A, knit around.

Rnds 29 and 30: With 2 strands MC, knit around.

Rnds 31–34: Work in large check patt.

Rnds 35 and 36: Work first 2 rnds of large check patt.

Rnds 37 and 38: With 2 strands MC, knit around.

Rnds 39 and 40: With 2 strands C, knit around.

Rnds 41–58: Work flower pattern chart on page 92.

Rnds 59 and 60: With 2 strands C, knit around.

BOTTOM

Knit bottom of bag with 2 strands C.

Rnd 1: *K2tog, K46, ssk, pm, K1, K2tog, K16, ssk, pm, K1, rep from *—136 sts.

Rnds 2–8: *K2tog, knit until 2 sts before marker, ssk, sm, K1, rep from * around—80 sts after rnd 8.

Rnd 9: *K2tog, K32, ssk, K1, K2tog, K1, removing markers as you come to them, rep from * around—72 sts.

Arrange sts evenly on 2 needles, graft sts tog using "Kitchener Stitch" (page 24). Weave in ends.

FINISHING

Fold facing (rnds 1–9) to outside of bag. With 1-yard piece of matching yarn, sew edge of facing to front of bag.

Knit 1-yard length of 4-st I-cord in each color, referring to "I-Cord" on page 30. Braid I-cord strands tog following steps illustrated below.

Bring strand 1 over 2, and 3 over 4.

Cross the 2 center strands, right over left.

Using sewing needle and thread, sew the strands together at each end of the I-cord. Lightly felt bag and I cord in washing machine. (See "Felting" on page 30.) Form bag over cereal box, straighten I-cord braid, and let dry.

LINING

1. Measure inner circumference at top of bag. Divide this number in half and add ½" for seam allowances. This is the width to cut lining.

2. Measure from top of bag down and across bottom and back to top. This is the length to cut the lining.

Example: The inside of bag measures 24" around. Divide 24" by 2 = 12". Add ½" for seams = 12½". From top to bottom and back to top, the bag measures 20"; this is the lining's length. The lining would be cut 12½" x 20".

3. With right sides together, fold lining in half crosswise. You need to cut out squares at corners of the fold. To determine the measurement of the squares, first measure width at the bottom of the bag, divide this number by 2 and subtract ¼" (seam allowance). This is the size of square to cut out. For example, if bag is 4" wide, divide 4" by 2 = 2". Subtract ¼" from 2" = 1¾". You would cut away a 1¾" square at each corner along the fold.

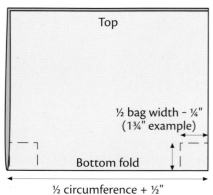

Top

½ bag width – ¼"
(1¾" example)

Bottom fold

½ circumference + ½"
(12½" example)

4. With right sides together and using ¼" seam allowance, sew side seams. Press seam allowances open. With right sides together, fold one side seam down centered directly over bottom fold of bag. Stitch as shown using a ¼" seam allowance. Repeat for other side seam.

Flower Pattern
(multiple of 12 sts)

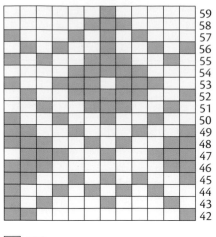

☐ MC
■ CC

5. Fold 1" of the top raw edge of lining to the wrong side and press. Turn lining so wrong side faces out and insert into bag. Pin in place.

6. Cut I-cord braid the length you want the strap (my sample is 31"). Baste strands together at each end of I-cord.

7. At sides on top of the bag, insert the strap ends between bag and lining. Pin in place. Using sewing needle and matching thread, sew top of lining to the bag, stitching securely through the straps.

8. Make a 3" piece of I-cord for button loop. Sew I-cord ends to top center of the back. Sew a button to the center front of bag.

Water-Bottle Holder

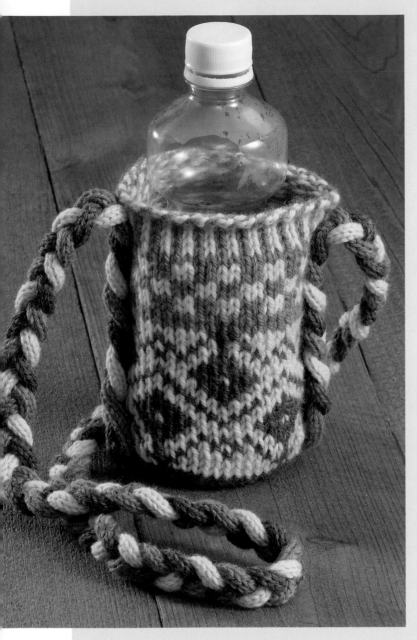

Practice the stitches and techniques for the Flower-Border Bag on this cute water-bottle holder.

Using "Two-Strand Long-Tail Cast On" method (page 13), circular needle, and 1 strand each of MC and A, CO 48 sts (not counting slipknot). Sl 24 sts to 2nd circular needle. Sl first st pw and beg working in the rnd, being careful not to twist sts.

BODY

Rnds 1-6: Knit around in stripe patt.

Rnd 7: With 2 strands of B, knit around.

Rnds 8-13: With 1 strand of MC and 1 strand B, work in large check patt.

Rnds 14-15: With 2 strands of B, knit around.

Rnds 16-33: Work in flower patt following chart on page 92.

BOTTOM

Alternate 2 strands of A as for Fair Isle, to shape bottom.

Rnd 1: *K2tog, K8, ssk, pm, rep from * around—40 sts.

Rnds 2–5: *K2tog, knit to 2 sts before marker, ssk, sm, rep from * around—8 sts at end of rnd 5.

Rnd 6: K2tog around, removing markers as you come to them—4 sts.

Cut strands, leaving 6" tails; thread tails on tapestry needle and slip through rem sts. Cinch tight and weave in ends.

STRAP

Make one 60" length of 4-st I-cord each from MC, A, and C. Braid I-cords together to make strap. Use sewing needle and matching thread to sew strap ends securely to opposite sides of holder, starting each end at the base and running cord up outside of holder. If desired, felt lightly for firmness.

Resources

If you can't find the tools and supplies you need at your local yarn shop, you can find the yarns and tools used in this book through the following companies.

SUPPLIES

Bond America
Embellish-Knit (creates I-cord)
800-862-5348
www.bond-america.com

Jo-Ann Fabric and Craft Stores
Embellish-Knit! (creates I-cord)
www.joann.com

YARNS

Berroco (wholesale)
800-343-4948
508-278-2527
www.berroco.com

Black Water Abbey Yarns (wholesale)
720-320-1003
www.abbeyyarns.com

Cascade Yarns (wholesale)
www.cascadeyarns.com

Cherry Tree Hill
802-525-3311
www.cherryyarn.com

Curious Creek Fibers (wholesale)
619-280-2404
www.curiouscreek.com

Dale of Norway/Dalegarn (wholesale)
802-383-0132
www.daleofnorway.com

Karabella Yarns (wholesale)
(212) 684-2665
www.karabellayarns.com

Mission Falls (wholesale)
514-276-1204
www.missionfalls.com

Mountain Colors (wholesale)
406-961-1900
www.mountaincolors.com

Rauma Yarn distributed by Arnhild's Knitting Studio (wholesale)
515-451-0584
www.arnhild.com

BIBLIOGRAPHY

Bordhi, Cat. *New Pathways for Sock Knitters, Book One.* Friday Harbor, Washington: Passing Paws Press, Inc., 2007.

Jönsson, Kerstin. *TVÅÄNDS STICKNING.* Boras: Dahlins Tryckeri AB, 2003.

Ling, Anne Maj. *Two-End Knitting*, Pittsville, Wisconsin: Schoolhouse Press, 2004.

Dandanell, Birgitta and Danielsson, Ulla. *Twined Knitting.* Loveland, Colorado: Interweave Press, 1989.

Stanley, Montse. *Reader's Digest Knitter's Handbook.* Pleasantville, New York: Readers Digest, 1993.

Roberts, Louise. *1,000 Great Knitting Motifs.* North Pomfret, Vermont, 2004.

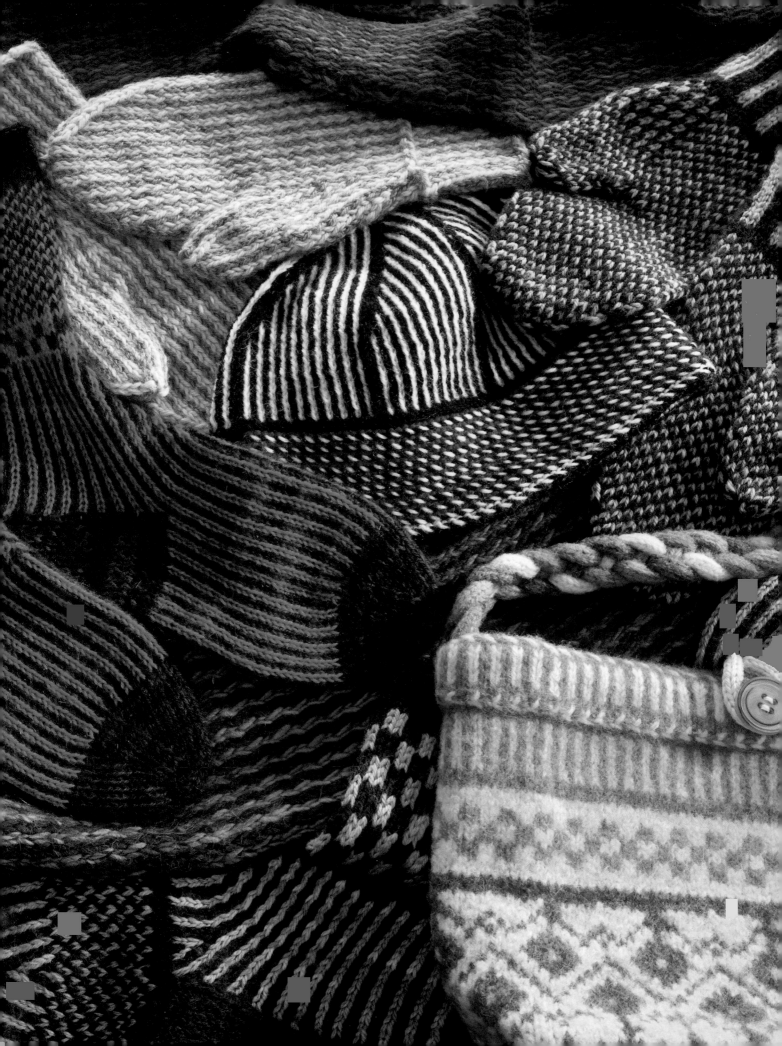

Knitting and Crochet Titles

ACCESSORIES
Crocheted Pursenalities
Crocheted Socks!
Kitty Knits
Pursenalities
Pursenality Plus
Stitch Style: Mittens
Toe-Up Techniques for Hand-Knit Socks, Revised Edition

BABIES, CHILDREN, & TOYS
Gigi Knits...and Purls
Knitted Finger Puppets
Knitting with Gigi
Too Cute!

CROCHET
365 Crochet Stitches a Year
Amigurumi World
A to Z of Crochet
Contemporary Crochet—NEW!
First Crochet

KNITTING
365 Knitting Stitches a Year
All about Knitting
A to Z of Knitting
Beyond Wool

Cable Confidence
Casual, Elegant Knits
Chic Knits
Fair Isle Sweaters Simplified
Handknit Skirts
Knit One, Stripe Too
The Knitter's Book of Finishing Techniques
Ocean Breezes
Simple Gifts for Dog Lovers
Simple Stitches
Skein for Skein
Stripes, Stripes, Stripes
Together or Separate
Top Down Sweaters
Wrapped in Comfort

LITTLE BOX SERIES
The Little Box of Crocheted Gifts
The Little Box of Crocheted Throws
The Little Box of Knitted Gifts
The Little Box of Knitted Throws
The Little Box of Socks

SOCK KNITTING
Knitting Circles around Socks
More Sensational Knitted Socks
Sensational Knitted Socks
Stitch Style: Socks

Our books are available at bookstores and your favorite craft, fabric, and yarn retailers. If you don't see the title you're looking for, visit us at **www.martingale-pub.com** or contact us at:

1-800-426-3126
International: 1-425-483-3313
Fax: 1-425-486-7596 • **Email:** info@martingale-pub.com

Martingale®
& C O M P A N Y
America's Best-Loved Craft & Hobby Books®
America's Best-Loved Knitting Books®